Men's Neckwear

L660 L136

-Pure silk; full assortment of this sea-
latest designs in light, dark and medium
s'; wide flowing-end shape; 1 doz. to box,
doz., **$1.75**

- Latest designs in this season's, fancy
reversible shape; can be worn on both
assorted designs to doz.; 1 doz. in box,
doz., **$1.75**

'S COAT STYLE
BLANKET ROBES

Made from
extra qual-
ity Blanket,
cut in uni-
versal sizes,
2 pockets, 1
on either
side, latest
coat style
with 3 large
buttons and
buttonholes
on front, roll
collar; collar
and edges
trimmed
with heavy

ad our
tee—on

S DOUB
ordered

Men's Pajamas

G62 G65

G62—Best quality Percale, with assorted
black, lavender and blue cluster stripings, 4
white buttons with mercerized silk frogs,
military cut collar, pocket, double stitched
shoulder seams, curved armholes; pants to
match with drawing string,
doz. suits, **$9.00**

★ G65—Extra quality plain white Corded
Madras, military cut collar, large pearl
buttons on front, frog trimming, pocket;
pants to match, with drawing band; ¼
doz. in box doz. suits, **$11.25**

MEN'S FLEECED RIBBED UNION SUITS

Solid sizes, 34 to 44. Packed ⅙ doz. in
box. Underwear of this character is increas-
ing in demand each year. They are cut on
scientific principles and are guaranteed to
fit perfectly. Do not hesitate to have a com-
plete line of the season's best sellers in your
stock.

★ G5250 — Egyptian
color ribbed knit
yarn, fine even gauge,

★ G800—
Silver
Gray, extra
heavy 2x2
ribbed knit,
V-shaped
neck,
heavy
weight,
covered
seams,
curved
armholes,
tight-fit-
ting at
waist,
doz.,
$4.00

Men's Night Shirts

Solid or assorted sizes, 14½ to 18. Packed
½ doz. in box.

G5011 — Plain white
Muslin, asstd. fancy
stitching down front,
around collar and
pocket, sloped shoul-
ders, curved arm-
holes, double stitched
throughout,
doz., **$4.35**

G5010 — As G5011, ex-
cept made with Mili-
tary collar,
doz., **$4.35**

G5015

n white Mus-
ront, around
hed pointed-
ders, curved
doz., **$6.50**

ite Cambric,
silk stitching
fs, flat felled
sloped shoul-
doz., **$8.25**

HIRTS

with 12 but-
tons, set-in
curved arm-
holes with
ribbed cuffs;
colors: Navy,
Black, Brown
and Tan; sizes
38 and 40 only.
doz., **$15.00**

G5111—
Fast
Black,
cut toe,
seam-
less heel,
sewed
on ribbed
top,
doz., **45c**

★ G490—Assorted narrow stripings of slate,
lavender and blue, extra good quality
white Percale, splendid weight, detached
golf collar, coat-style cut which opens the
entire length, wide wristbands, double
stitched shoulder seams and curved arm-
holes doz., **$4.00**

JACOB EPSTEIN

Jacob Epstein

by

LESTER S. LEVY

MARAN PRESS
Baltimore, Maryland
1978

Library of Congress Catalog Card Number: 78-50724

ISBN: 0-916526-05-4

Preface

This is the story of a remarkable man.

Arriving in the United States as a boy, less than fifteen years old and with no family or well-to-do acquaintances who might assist him, he set out to achieve financial independence. Eventually, through hard work, dedication of purpose, ingenuity, the highest integrity, and a profound love of his fellow man, he became a living legend of enlightened leadership.

It was the privilege of the writer to know Jacob Epstein, to observe his generous impulses, and to join the thousands of Baltimoreans whom he instructed, by personal example, in the joy of giving.

Had this book been compiled twenty years earlier it might have been possible to fill in details of Mr. Epstein's early life in this country that are unavailable now. Moreover, the recollections of his friends and acquaintances do not always tally, and it has sometimes proved difficult to judge which person's memory is the more accurate one.

But there is one point on which all who have been consulted agree; Baltimore never had a more valiant citizen nor one more devoted to his city. And all concur in accepting another fact; the Baltimore Jewish community found in Jacob Epstein a leader who set the standard of communal giving on a plane that had never theretofore been envisioned.

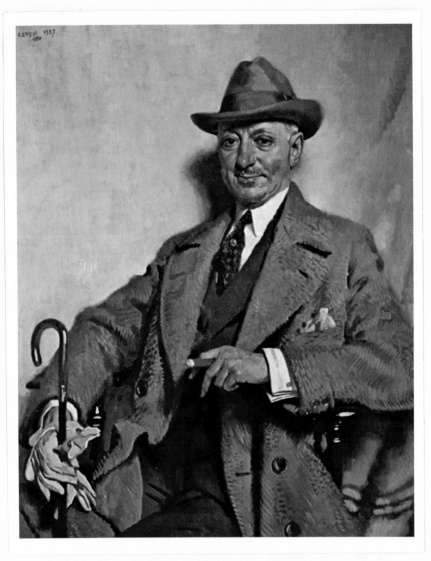

PORTRAIT OF JACOB EPSTEIN BY SIR WILLIAM ORPEN
COURTESY EPSTEIN COLLECTION
BALTIMORE MUSEUM OF ART

The Early Years and Family Life

The youth was tall for his age, and lanky. His parents had named him Jacob when he was born, in Tauroggen, Lithuania, on December 29, 1864. As a boy his friends knew him as Yankele.

Like most Jewish communities in eastern Europe, Tauroggen felt the weight of oppression. Jews were restricted in their choice of occupations and in their areas of residence; nearly all of them were poor; and their sons were subject to conscription in the army in their teens.

Isaac and Jennie Epstein were hard-working people. Jennie had all she could do to take care of her growing family. Isaac was a drayman. Much of his time was spent hauling grain and hides from Tauroggen to Koenigsburg and Tilsit, a few miles across the border in eastern Germany.

Isaac Epstein had a good horse, of which he took the best of care. Jacob became devoted to the horse at an early age.

As the boy approached his teens his father would place him in the wagon and the two of them would set out, in any weather, to deliver their cargo. In winter it was bitter cold, and at times the going was tough and treacherous. Often the boy had to shovel a path so that the horse could get through. Isaac was so poor that often he could not afford lodging after selling his wares in Germany. Consequently, he and Jacob were often forced to sleep under the wagon to protect themselves from the elements. In later years people used to remark on the size and coarseness of Jacob's knuckles. He would always attribute this to their having first become reddened and swollen when he traveled through the heavy snow with his father on the way to Tilsit, Germany.

Much of the merchandise that Isaac Epstein transported was on consignment from another Tauroggen resident, named Klein. Klein had a son, Isaac Charles, who was Jacob's fastest friend. Often the two boys talked about the possibility of going to America. This was a dream shared by many Jews in Lithuania, and for many it was a dream that would one day be realized. For the two boys the dream became a reality at an early age.

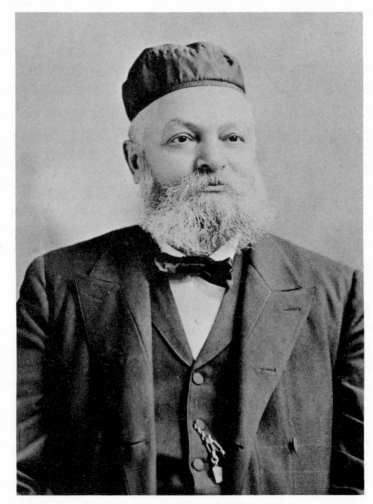

ISAAC EPSTEIN

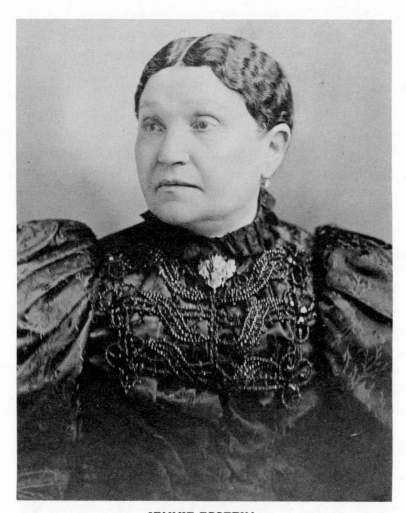

JENNIE EPSTEIN

When they were fourteen years old a benefactor made his appearance. He was not an angel from heaven, or even a stranger. As a matter of fact, he was Isaac Charles's father. Mr. Klein was fortunate enough to have saved a little money. Realizing that his son would soon be drafted into the army, and sympathetic to the boy's desire to emigrate and take with him his close friend Jacob Epstein, Klein advanced funds to purchase tickets to America for the young men.

The two boys left Tauroggen in the spring of 1879, two years before the first mass movement westward of the eastern European population. They boarded a steamer in Bremen and arrived at Castle Garden in New York with very little money left in their possession. It was enough to get them to Baltimore, where Jacob believed he could locate some acquaintances and where a few of young Klein's relatives had established themselves.

There are several different reports of Jacob Epstein's first place of residence. Some members of the Klein family indicate that they took care of him. Laura Epstein says that he was helped by her father, Joseph Strauss, who secured quarters for him at Samstag's boarding house.

The two boys knew only one means of livelihood, that of the itinerant peddler. In those days there were a few wholesale houses that would give credit to a young man if he wanted to go out into the country to peddle the kind of merchandise the housewives needed—oilcloth, kitchenware, pins, thimbles, eyeglasses, bombazine, calico. Jacob Epstein filled his pack and headed west.

His first stop of any importance was in Hagerstown, Maryland, where he was kindly received. From there he continued to Western Maryland, West Virginia, and Pennsylvania. He had had no knowledge of English when he arrived in the United States, but he studied assiduously and was soon able to acquire enough of the language to use it in his selling approach. He was an excellent salesman, with a pleasing personality, and was successful almost from the start.

In Pennsylvania he felt at home with the farmers' wives, many of whom were of German background, because he had learned German in his travels with his father. Always industrious, he never lost an opportunity to impress the housewives with his knowledge of the wares he carried. Often he would ask if there were chores to be done on the farm or around the house in return for bed and board, and frequently he was successful.

Slowly he built up a little capital. By the beginning of 1881 he had accumulated six hundred dollars.

Jacob was now sixteen years old. Peddling did not appeal to him as a way of life. He felt fully capable of operating a store of his own, and he wanted one in Baltimore. Charles Klein had followed a road similar to Jacob's. He had relatives in West Virginia, and the two young men knew that they would have to go different ways. Before doing so, however, they posed together for a picture so that they would have a tangible remembrance of their friendship.

After a diligent search Jacob found a small place in South Baltimore at 48 West Barre Street, and this is where he began the enterprise that was eventually to become a giant. The little store had an eighteen-foot front and was thirty feet in depth, but it was large enough to stock all the merchandise Jacob could afford to buy at that time.

He worked intensively, long hours, often till midnight. His sole thought was to develop a growing business; well *almost* his sole thought. He had one other primary concern—his health. He exercised daily. He read every article about health that he could find. These articles made him resolve on, and adhere to, strict eating habits. He believed that prunes were health builders. When asked about his devotion to prunes as a source of lubrication, he would advise his companions, "If you are going to eat prunes for your digestion, start with one, then two, then get up to twelve. After twelve, stop." He liked simple, spare meals but had favorite foods—lentil soup, hearts of lettuce without dressing, gefilte fish, noodle charlotte, and boiled chicken. He never drank water with his meals. In later years, he used to admonish grandchildren to follow this practice, asking them, "If a steak were placed on your plate, would you pour water on it?"

As soon as he had started to save a little money, he sent for the other members of his family. His father sailed from Bremen in 1882 on the S.S. *Herman* and arrived in Baltimore on the thirty-first of May. The following year, Jacob arranged for his mother, his sister, Rose, and his brother, Nathan, to come to Baltimore, and he established them in a house in the 200 block of South Eutaw Street. An uncle, Solomon, made his own way over and eventually associated himself with Jacob's enterprise.

It was soon evident that the traits of generosity that Jacob Epstein was to display so magnificently in later years were first developed from the

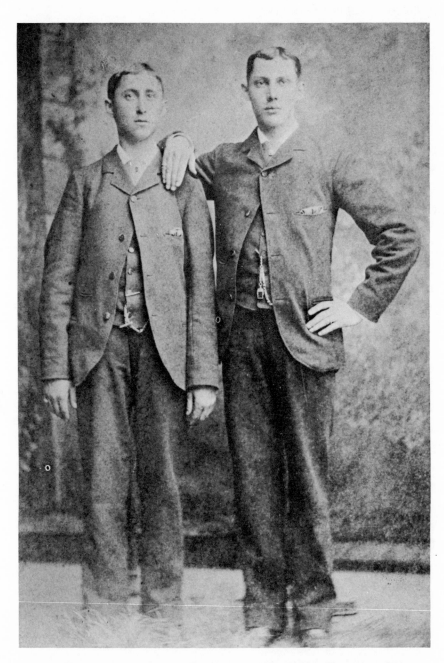

JACOB EPSTEIN (RIGHT) AND I. CHARLES KLEIN c 1881

example set by his parents. On Friday night, Jennie and Isaac used to invite poor neighbors to their home for bread and cake and coffee. When people asked Jennie why her cake was so much more delicious than anyone else's, she would say it was because she "put more love into it." Her son would often tell this story at charity meetings, and say that when his mother weighed out sugar for her cake, after what she had decided was the proper amount, she would add a little extra; that, she said, was what made her cake taste best. Mr. Epstein would then explain that all his life he had followed this policy in his approach to charity; he would first contribute what he thought was the proper amount and then he would add a little bit extra.

When Jacob Epstein was twenty-three years old, he fell in love. The girl who so attracted him was Lena Weinberg, whose father had immigrated to America many years earlier. Lena was Baltimore born and bred; a fine-looking brunette, whose mother plied her trade as a milliner. Lena was charming and considerate of everyone about her. She had other suitors; in fact, she had been betrothed to a young man from New York, Shirleigh Baum, who died shortly after their engagement had been announced.

Lena and Jacob were married on July 22, 1888. They made their first home at 652 West Fayette Street near Fremont, and it was there that their two daughters were born, Ethel in 1889 and Marian in 1890. After the birth of the two girls, the family moved to Northwest Baltimore and took rooms at the boarding house run by Mrs. Rose Etting, at 1627 Madison Avenue.

By now the family had suffered a great misfortune. Lena Epstein had become seriously ill after the birth of her second child. She became an invalid for undiagnosed reasons and Mr. Epstein engaged a housekeeper to conduct the affairs of the household.

As the years rolled by and his business prospered, Mr. Epstein found time to participate actively in the affairs of the city he now loved, and in charitable works through which his name became a by-word in local philanthropic agencies.

The family moved again, this time to 1729 Park Avenue, a substantial house in a neighborhood where some of the Baltimore "gentry" lived. Mr. Epstein continued to work long hours, which made it difficult for his children. Ethel and Marian were growing up now and were enrolled at the Girls' Latin School for their primary and secondary school education.

During this period Mr. and Mrs. Epstein managed to find the time to take their daughters to Europe during the summer as they wanted to encourage them to master foreign languages. Both girls completed secondary school at Girls Latin, but Marian, after graduation, was sent for a year to Simonsohn's Pensionnat, a finishing school in Berlin, Germany.

The most prominent Jewish social club of that period was the Harmony Circle. Each year several dances were given. At the first seasonal ball, usually held on the Wednesday night preceding Thanksgiving, a number of young ladies of about eighteen years of age, the daughters of socially prominent families, were introduced to society as debutantes.

The two Epstein girls were likely candidates for such social prominence. At Lehmann's Hall, where a ball was held in the fall of 1907, Ethel Epstein made her debut. Each debutante had a partner; Ethel's was A. Ray Katz, who held the position of Master of Ceremonies and who was, therefore, expected to lead the first dance. The two young people made a handsome couple as they stepped onto the dance floor to start the waltz.

At a later Harmony Circle affair, Marian made her debut in similar fashion and with great charm. The newspapers went into much detail about the elaborate costumes of the debutantes; readers in those days loved such intimate details.

In 1908, Jacob Epstein had purchased a beautiful house on Eutaw Place known as "2532" (although there never was a number on the door) facing Druid Hill Park, which had been the dwelling of General Alfred E. Booth. Soon after the Epstein family moved in, they filled their home with objects of art; it became a veritable art gallery in a short space of time. The old masters acquired in the 1920s were placed in the Moorish Room, so called because it was furnished in dark reds. The works of the French artists and the bronzes were in the white and gold drawing room, the den, and on the impressive stairway, which divided halfway up to the second floor.

In April, 1909, Mr. and Mrs. Jacob Epstein announced the engagement of their daughter, Ethel, to A. Ray Katz. The popular couple were married at the Hotel Belvedere on November 1, 1909, before a large group of friends and relatives. After a wedding trip to California, they returned to 2532 Eutaw Place, where they made their home and where Ethel ran the household and acted as Mr. Epstein's hostess on the occasions when he entertained.

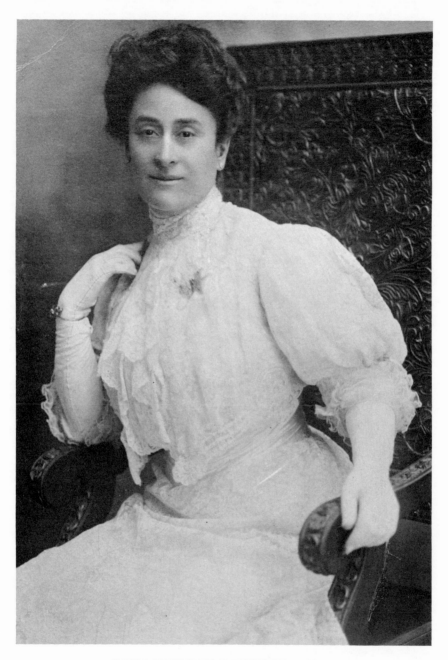

LENA WEINBERG EPSTEIN c1898

SCHOOLGIRLS ETHEL AND MARIAN c1900

There was never any question as to how Ray Katz intended to support his wife. On January 8, 1910, the Baltimore *Sun* printed this brief notice: "A. Ray Katz has been admitted as co-partner of the firm of Jacob Epstein, Nathan Epstein, and Abraham I. Weinberg, trading as the Baltimore Bargain House, Jacob Epstein, Proprietor." So that was that.

Next it was Marian's turn. On January 31, 1910, Mr. and Mrs. Epstein gave an enormous reception and dance at their home in honor of their debutante daughter, with all details again published in the press.

Marian, too, was destined to be a young bride. On May 10, 1910, her engagement to Sidney Lansburgh was announced. Dr. William Rosenau officiated at their wedding on December 10, 1910, a lavish affair held at the home of the bride's parents. The young couple took a two month wedding trip to Europe and then settled down in their new home at 2226 Linden Avenue.

As may have been anticipated, Sidney Lansburgh was eagerly welcomed by his father-in-law as a new business associate, the newspaper announcement reading, "Sidney Lansburgh has been admitted as a co-partner in the firm trading as the Baltimore Bargain House, Jacob Epstein, proprietor."

Mr. Epstein had installed his parents in a pleasant house at 1630 McCulloh Street. It was there that Jennie Epstein, who had been known as the "Mother of Charity in South Baltimore" died on March 5, 1911. Her funeral services were conducted by the Reverend Samuel Elkin, who had been the rabbi of her old synagogue on Hanover Street, Congregation Anshei Emunah.

Isaac Epstein then moved to 2026 McCulloh Street near the Shearith Israel Synagogue, which he attended regularly. During his later years, this tall, well-groomed, white-bearded patriarch had been obliged to forego the pleasure of earlier times when he used to ride horseback in Druid Hill Park. In 1912 his health began to fail, and he died on December 25, less than two years after his wife's death. A delegation from the United Hebrew Charities, of which he had been a director, attended his funeral, where services were conducted by Rabbi Elkin of the Hanover Street Synagogue (Isaac Epstein had at one time been its president) and Rabbi Shepsel Schaffer of Shearith Israel.

The addition of Jacob Epstein's two able sons-in-law as partners was a

"PA" AND "MA," ETHEL AND MARIAN IN EUROPE c1905

source, not only of much pleasure, but of substantial assistance in the administration of the constantly growing business. It gave Mr. Epstein more time to devote to his philanthropic and civic interests — not that they had been neglected theretofore, but an increasing number of causes was clamoring for his support. One was The Johns Hopkins University. Mr. Epstein, a man with limited formal schooling, was cognizant of the role of an institution of higher learning like Johns Hopkins, and time and again after the university moved, at great expense, to Homewood in 1916, he helped in its efforts to face the annual deficit. In 1923 he set up an endowment fund that has a present value of about $150,000, and he also left a substantial amount to the university in his will.

Another institution receiving his help, one of a different character, was the Catholic Church. Mr. Epstein had developed a warm relationship with James Cardinal Gibbons, and the charitable activities supervised by the church had Mr. Epstein's sympathetic cooperation. Not only did he give generously to them, but he attended and spoke effectively at fund-raising functions. A letter written in October, 1916, by a director of the campaign for funds for the Saint Vincent de Paul Society, reads as follows: "Let me thank you for your address last night. You presented the manner of securing funds for charity in such a common-sense way that the workers were all inspired by it."

Jacob Epstein now began to find more time for relaxation. In the early 1920s he began to spend his vacations in Los Angeles, a city to which he was strongly attracted. He even indicated a desire to move there because of the climate, if both or even one of his daughters would move with him. But both declined because of their strong ties to Baltimore.

Later he began to take trips to Europe, and found that he enjoyed them immensely. After a while, they became almost routine, until eventually World War II, and his declining health, forced him to discontinue them.

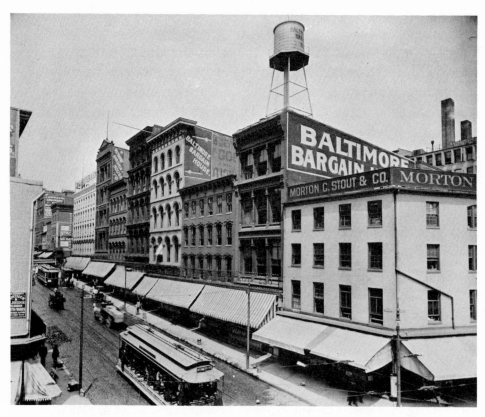

THE BALTIMORE BARGAIN HOUSE IN THE EARLY 1900's.
NOTE THE TROLLEY CARS AND HORSE-DRAWN VEHICLES.

The Baltimore Bargain House

The sixteen-year-old boy had $600, the result of nearly two years of arduous selling experience as an itinerant peddler. Moreover, he had enormous energy and complete confidence in his overall ability. The triple combination was enough to establish him in the mercantile business.

The 1881 model of the Baltimore Bargain House-to-be was an eighteen by thirty-foot store at 48 Barre Street in South Baltimore. The rental figure is unknown, but it was certainly modest, as was the room in which the wares were displayed.

From the outset Jacob Epstein set out to do a jobbing business with the peddlers who played such an important part in those days in bringing needed wares, and entertaining stories, to rural housewives. His own experience on the road had taught him what types of merchandise were in the greatest demand: oilcloth, piece goods for dresses, patterns, kitchenware, pins and needles and thimbles. Trusting the peddlers, he was willing to sell to a number of them on credit, which was unobtainable from most of the larger wholesale houses. As a result, his business prospered from the very beginning.

In 1883 he took a partner, Adolph Rosenstein, and the relationship lasted for two years. Rosenstein took some of his partner's merchandise on the road and competed with other salesmen, probably in North Carolina and West Virginia. Strange to say, there is no further detailed history of the brief partnership, nor of what became of Mr. Rosenstein. Records indicate that in 1885 he was employed by others as a salesman, and then—whoosh! His name never reappears in the *Baltimore City Directory* or in the annals of any Baltimore congregation.

By 1885 Mr. Epstein, having parted company with the mysterious Mr. Rosenstein, had taken larger quarters at 100 Barre Street. Now he needed additional sales and clerical help, so he engaged two assistants, one of whom was Solomon Coplon (whose sons, nearly forty years later, built a chain store business that Mr. Epstein acquired for himself in the

15

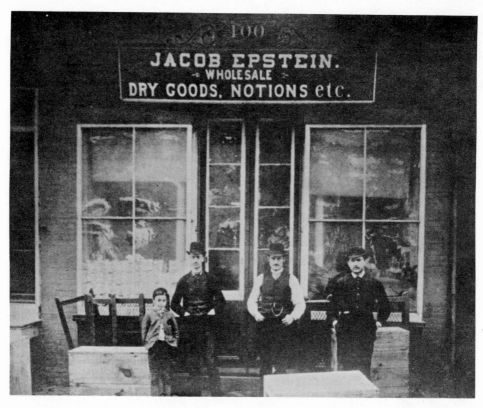

STORE AT 100 BARRE STREET. NATHAN EPSTEIN, JACOB EPSTEIN, SOLOMON COPLON, UNIDENTIFIED CLERK c1885

mid-1920s.) A photograph of the young proprietor standing before the enlarged Barre Street establishment, flanked by his clerks and his little brother Nathan, is found elsewhere in this book.

The 1886 *Baltimore City Directory* listed Mr. Epstein as a purveyor of "fancy goods and notions," and the following year as an "importer, jobber, and wholesale dealer in dry goods." His business address changed again; the second Barre Street store had become too small, so he rented the first floor of a building at 34 Hanover Street. And when he outgrew that space, he acquired the upper floors as well.

His customers now included small retail stores from the immediate area, and the volume they represented accounted for much more than that required by the peddlers. Moreover, the stores were in need of articles of clothing, jewelry, and other wares. To supply a larger proportion of their requirements, Mr. Epstein added one item after another to his stock.

In 1890, when he took another partner, Israel Levinstein, customers were coming in from various parts of the south. Many had been Jewish peddlers who eventually opened their own businesses in small southern towns. They were still not proficient in English; their most fluent language was Yiddish. For that reason many of the bills of Epstein and Levinstein were written in Hebrew script. One such bill made out to a customer in Raleigh, North Carolina, in 1892, has been preserved. It lists thirty separate items, amounting to $28 in all. Included are satchels at $2.25 a dozen; dresses at $3 per dozen; a package of pins, 13¢; thimbles, 9¢. There are 2 dozen socks at 65¢ a dozen; baby shawls for 75¢ a dozen; ladies' vests at $4.50 a dozen, and sheets at $3 a dozen.

For nearly four years the partners toiled together to build up the business. Their work force expanded to two hundred employees. Then came the parting of the ways. Levinstein, a deeply religious man, wanted to close the store on Saturdays. Jacob Epstein felt that Saturday was the best business day and insisted on keeping the store open on that day. More importantly, Mr. Epstein at this time was anxious to circularize his customers by sending out catalogs advertising the merchandise for sale, a project to which Mr. Levinstein was adamantly opposed.

The outcome was inevitable. The two men parted company, but on the most amicable terms. It was agreed that Mr. Epstein would continue at the Hanover Street address with the sale of fancy goods and notions, but that

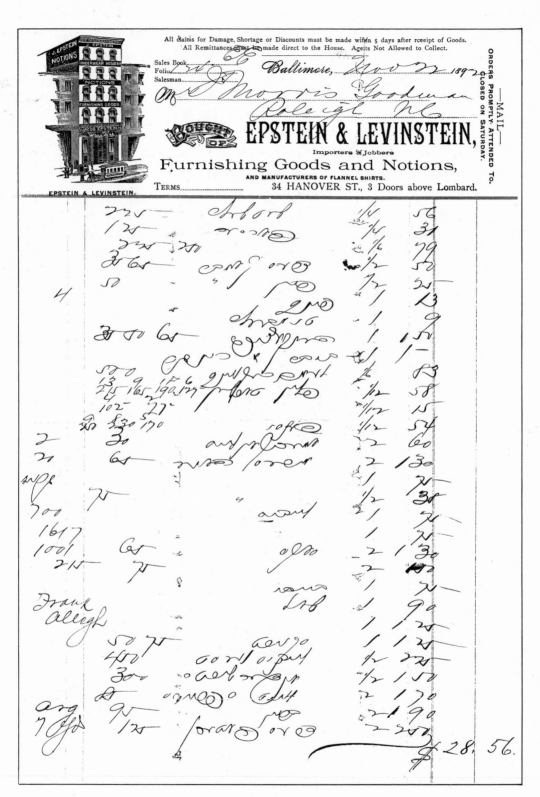

BILL IN HEBREW SCRIPT 1892

for the next twenty years he would discontinue the sale of shoes, which had been an important item in the business. Mr. Levinstein, on the other hand, would conduct his shoe business elsewhere.

Still the volume at Hanover Street continued to expand so rapidly that in the fall of 1894 Mr. Epstein was forced to leave the cramped quarters there and move to a better location at 216 West Baltimore Street. Now he promoted his new trade name, "The Baltimore Bargain House," which appeared above the door of his store and on all his stationery.

The catalogs that Mr. Epstein began to issue were an immediate success. Eventually they were distributed on a monthly basis; the yearly total was one million copies. Each catalog, at the time it was issued, contained a statement giving the current financial condition of the Baltimore Bargain House.

For some years the growth of the business had been noted with admiration by the Baltimore business community. In the fall of 1902, in one of a series of articles on "The Strong Men of Baltimore" by an editor of the Baltimore *Herald* (who called himself "The Learner") Mr. Epstein was the subject. Here is a quotation from it:

Epstein is a plant that is continually outgrowing its potting
Epstein began life by getting onto a strong plank, and they call that
plank "keeping his word." He has that plank yet. It is not for sale
. . . . but you can copy it.

Disaster threatened the Baltimore Street store in February, 1904, when the great Baltimore fire reached the east side of Baltimore and Liberty streets. But the Bargain House's employees stood on the roof of their building and extinguished the flying sparks that fell on it. Mr. Epstein himself had hot coffee and sandwiches for the firemen and fed them day and night. Not only that, but he fed and watered their horses as well.

In May, 1904, a new annex was added on Fayette Street, in the rear of the Baltimore Street store. By then the work force had risen to eight hundred clerks, with nearly one hundred bookkeepers.

The Baltimore *News* now reported that Mr. Epstein's sales ran over $1 million in some months and that on some days he shipped ten thousand cases of goods. He had thirty thousand customers. When the *News* asked what had brought his success, Jacob Esptein said: "Adaptability for the

19

AFTER TEN DAYS, RETURN TO

216 W. Baltimore Street, Baltimore, Md.

BALTO. BARGAIN HOUSE
216
BALTO. BARGAIN HOUSE
FURNISHING GOODS
NOTIONS
BALTO. BARGAIN HOUSE

BALTIMORE. MD.
NOV. 23
6 30 PM
1894

Mr G T Brown
Brownsville
Md

EARLIEST BALTIMORE BARGAIN HOUSE STATIONERY 1894

work undertaken; judgement, with courage to execute it; and, of course, integrity and hard work.''

In 1905, as sales still mushroomed, the property at the corner of Cross and Wicomico streets was purchased as a warehouse. In 1906 the Baltimore Street operation had become so crowded that the properties at 212 and 214 West Baltimore Street were acquired, and shortly thereafter still more property in the Baltimore Street block, as well as in the Fayette Street block, were added. The purchases of these and other properties were part of Mr. Epstein's plans for ownership of surrounding real estate as protection against competition and as a means to satisfy expansion needs.

To carry its merchandise to public transportation facilities, the Baltimore Bargain House had twenty-five drays, and the finest draft horses in the city. Mr. Epstein had a special fondness for horses, acquired in the days when he and his father drove from Tauroggen to Tilsit with the loads of wood and hides. He enjoyed entering his animals in horse shows, where they often won prizes.

At this time an export department was established, and in addition to the enormous volume of business in the southeast, trade was solicited with Puerto Rico and Cuba, as well as the British West Indies and Newfoundland. The export department included a Spanish correspondent to handle mail from the Spanish-speaking customers.

Mr. Epstein continued to modernize his operations. By 1905 he had fourteen elevators in one building. In 1906 he purchased his first electrical truck, which had a capacity of five tons and traveled at an average speed of five miles per hour. By 1907 four such trucks were in operation. However, this did not eliminate his draft horses, and the twenty-five teams continued in use.

The Baltimore Bargain House operated its own electric light and power plant. Electrical conveyors moved the cases of merchandise from the packing department to the loading platforms, which could handle 3,000 pounds of freight per minute. The shipping cases, incidentally, were made in Mr. Epstein's own factory. The catalogs, too, were designed in the composing rooms of his printing plant but sent to the R. R. Donnelly Company of Chicago for printing. His buildings were equipped with the most modern sprinkler system; yet he continued to maintain a fire brigade for emergencies.

Mr. Epstein now had his own clothing plant, which employed several hundred people and operated in a property he had acquired around the corner on Howard Street.

An article in the *Wall Street Daily News* in October, 1907, said of Jacob Epstein: "He is the human live wire that connects every part of mental and material machinery of the store with every other part."

The successful development of the business may be laid to several factors; but three in particular indicate the gifted merchandising ability of Jacob Epstein.

The first was his complete confidence that his catalog would serve as his salesmen to the trade, thus giving him a decided price advantage over his competitors. Other wholesalers sold their merchandise through traveling salesmen, whose commissions ran anywhere from 7 percent to 10 percent. Jacob Epstein's catalogs were his salesmen. He figured their cost at 2 percent to 2½ percent, and the savings in selling costs were passed on directly to his customers. Thus, he could confidently announce as his motto—which was printed in every catalog—"More goods for same money; same goods for less money."

The second factor was Mr. Epstein's decision to mark in plain figures the prices of all the merchandise in his store, a practice that gave his customers full confidence and one that was not used by his competitors, who continued to mark their prices in code.

The third factor was the brilliant method Mr. Epstein used to lure merchants to the Baltimore market. In January, 1909, Mr. Epstein chartered seven ships from the Merchants and Miners Transportation Company, running to Baltimore from Jacksonville and Savannah. He offered to bring southern merchants on these ships to Baltimore without charge, regardless of whether or not they dealt with the Baltimore Bargain House. This novel idea proved a gold mine. Seven hundred store owners took advantage of the offer and came to Baltimore to purchase their wants— mostly, though not entirely, from the Baltimore Bargain House. The innovation was so successful that within a few months two more ships were added to the project, which attracted nationwide attention.

This was followed by offers of free excursions on the Baltimore and Ohio Railroad for merchants from West Virginia. Many took advantage of this opportunity.

In June, 1909, an editorial in the Providence, Rhode Island *Evening Bulletin* declared: "The Baltimore *Sun* has the optimistic audacity, not to mention selfishness, to wish that Baltimore had more Jacob Epsteins. If there are any more Jacob Epsteins, Providence would like one. It would not think of asking for more."

And still the business grew. In 1910 the rumor spread that Mr. Epstein was negotiating for property on Baltimore Street to the east of his place of business. It was reported that such a transaction would amount to more than $1 million. As a matter of fact, the purchase of the corner of Liberty and Baltimore streets, and the cost of the twelve story building that was erected there, came to $2 million. The building, which had 20,000 square feet of floor space on each floor, was the largest of its kind in the south. The real estate transaction alone was the largest in the mercantile history of the city. The show room occupied the corner building, while the buildings to the west were used for storage, delivery, and the various other functions necessary for the operation of such a large wholesale corporation.

Mr. Epstein was convinced that his customers would welcome a store that looked different from all the others, and would be particularly impressed if the first floor resembled that of a bank; so he ordered the floor made of marble. The cashiers and credit men had cages like those of bank tellers placed before their offices. As for the customers, they were more than impressed; they loved the whole thing!

One note may seem incongruous today; at the entrance to the store were large bolts of oilcloth. This was Mr. Epstein's own personal touch. Ever since his days as a peddler, he had learned that oilcloth was a real necessity in every home. Housewives lined their shelves and their bureau drawers with it; it covered table tops; it had a dozen other uses. It had always been a staple in practically every order placed with his company.

For years everyone knew he could buy oilcloth at the Baltimore Bargain House at ten cents a yard. One day one of Mr. Epstein's good customers came to him and said, "Your oilcloth is not competitive. Silberman and Todes are offering it at nine cents a yard." "Then," said Mr. Epstein, "you should certainly buy it from them." "But," said his customer, "they don't have any in stock at the present time." "Well, I'll tell you," said Mr. Epstein, "if I didn't have any in stock I would be glad to offer it to you at nine cents a yard."

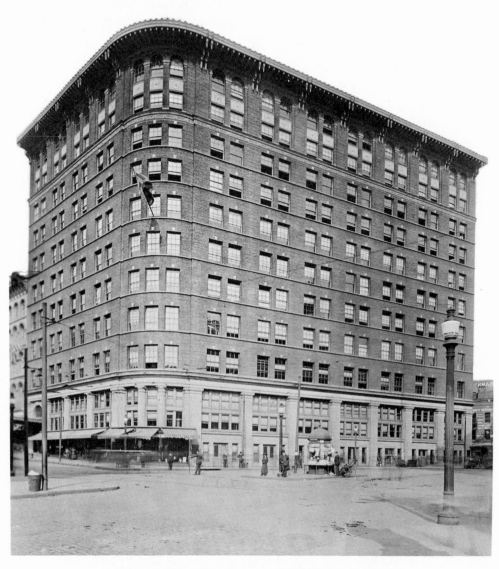

NEW BALTIMORE BARGAIN HOUSE BUILDING,
BALTIMORE AND LIBERTY STREETS 1912

Shortly before the building was thrown open to the public in 1912, a poem about it appeared in the Baltimore *Sun*. Baltimore at that time had a poet laureate named Folger McKinzey, known as the Bentztown Bard. Here, (in part) is the Bentztown Bard's tribute to the Baltimore Bargain House:

> Fronting with broad face on the busy street
> Its aspect massive, noble, leonine,
> Designed on simple graces, but complete
> The casual vision marks it strong and fine.
>
> . . . There it stands
> A monument to toil of heart and hands,
> Based on the small beginnings dating back
> Unto street stand and the oilcloth pack.
> The embryo store, the tiny wareroom, skill,
> To purchase wisely, sell with wisdom, till
> The little added to a little more
> Sets the emporium where the little store
> Stood in its small beginnings, and the end
> Is the skyscraper, with its lines that blend
> In perfect unison with street and town—
> A young life-effort's fitting knob and crown!
>
> The Tower of Trade upon the Muses calls,
> And song sees clear to set forth in clear light
> That not the steel, the brick, the mortar tell
> All of the story of this landmark bright,
> But that within its massive frame the spell
> Of all Time stands for in the trade of life
> Is centered firmly—here a human strife
> Against great odds, a boyish will and dream,
> Rises in cognate glory, floor and beam
> Builded on manly spirit, judgment, gift
> The inner self the outer self to lift,
> And having lifted to give self again
> Back in great gifts of charity to men!

25

Throughout the years of growth, Mr. Epstein realized that it was not always easy to be a pioneer. It was necessary to observe his most important competitors and to copy the innovations of others where they were applicable. Not only did he study the mercantile operations of other establishments in the United States, but whenever he traveled, whether to London, Paris, or Shanghai, he would observe merchandising methods he considered applicable to his own business. He was not a conservative businessman. He was always willing to take risks, and for him most of them paid off.

In 1912 the monthly catalog of the Baltimore Bargain House, called *The Baltimore Cost Reducer,* ran over four hundred pages. On the first page appeared the establishment's guarantee: ''All Baltimore Bargain House goods warranted exactly as represented and same grades as handled by other first class wholesale houses but lower in price on average. Same goods for less money; more goods for same money."

The terms to purchasers were most favorable. July, August, and September shipments were payable December 1. January, February, and March shipments were payable June 1. Some of the prices would make today's consumers blink their eyes. Men's dress shirts ran from $2.50 to $4.50 *a dozen.* Men's socks started at 75¢ *a dozen.* Women's petticoats started at $2.25 *a dozen;* cotton damask towels, 95¢ *a dozen;* stem-wind watches, 53¢; one-quart Mason fruit jars, 43¢ *a dozen.*

In an operation as large as that of the Baltimore Bargain House there had to be a number of credit managers. Each one was in charge of a different territory; and some were tougher than others. It is reported that the credit manager for West Virginia was extremely difficult, whereas the manager for Ohio was easy on his customers. As a result, a number of merchants from West Virginia moved their business to Ohio so as to be able to work with a more lenient credit manager.

Most of the time when out-of-town customers called to see Mr. Epstein for the first time, they would be ushered into the office of Mr. Nathan Epstein, who would receive them courteously. Incidentally, one of Nathan Epstein's duties was to purchase presents when they were needed for customers and friends, on occasions such as Bar Mitzvahs, confirmations, weddings, and the like. The presents were always modest; it is reported that Mr. Epstein held the cost of each gift at five to eight dollars.

At one time the store made a very advantageous purchase of silk shirts. Despite the attractive price, the shirts did not sell. Mr. Epstein, at a loss to understand the problem, visited the department, where he found that all his salesmen were wearing cotton shirts. He immediately ordered them to change to silk shirts; when customers saw the salesmen in their stylish attire, they soon purchased all the stock on hand.

Once, when he was attending a vaudeville show at the Maryland Theatre (a favorite Friday night diversion), he saw a magician lay a straw hat on the table and pull from it a rabbit, lengths of ribbon, flags, and other assorted articles. With his nice sense of humor, he sent for Fred Stern, his hat buyer, the following Monday morning and, describing the remarkable hat and all that came forth from it, said "Mr. Stern, I want you to put that style in your hat line!"

Mr. Epstein was a stickler for integrity in advertising. He would say to his associates, "Don't misrepresent. And don't let the truth sound like a lie."

As the business continued to expand, it required another enormous structure for receiving, storing, and shipping. On Wicomico Street, between Scott and Ostend, an eight-story building, consisting of 50,000 square feet per floor, for a total of 400,000 square feet, was erected for this purpose. Sales had mushroomed to about $16½ million, and there seemed to be no end in sight. To protect himself further, Mr. Epstein began to buy property on the south side of Baltimore Street, directly across from the Baltimore Bargain House. Half a dozen moderate-sized properties were thus acquired at a cost of nearly $200,000.

Before the United States entered World War I, Baltimore was visited by one of Germany's finest submarines, the *Deutschland,* and a tremendous amount of attention was created in the city. Mr. Epstein capitalized on the interest by reproducing a miniature mechanical model of the U-boat, which he placed in a window of his store. The boat, about six to eight inches long, was shown in full operation. It journeyed between replicas of Europe and the United States, and was able to dive, move under water, surface, and operate a periscope and conning tower. The little model was shown as leaving the port of Bremen, passing through the North Sea and English Channel, across the Atlantic, and up the Chesapeake Bay to Baltimore. All day long crowds congregated before

27

the window. A placard in the window read: "The *Deutschland*'s under-the-sea sailing and the Baltimore Bargain House's under-the-counter sales are both results of up-to-the-minute organization and efficiency."

In February, 1917, Mr. Epstein wrote an article entitled "Why Baltimore Can Sell Same Goods Cheaper Than Other Markets." He stressed six points: accessibility, (half the population of the United States lived within five hundred miles of Baltimore); facilities; raw materials (shorter haul by rail from all points west and south); power, light and heat (lower fuel cost and cheaper power, abundant water power); cost of living; labor conditions. He concluded, "So come to Baltimore. Remember that the merchant too busy to come to the market is like a carpenter too busy to sharpen his tools."

By the winter of 1917 the Baltimore Bargain House was operating a clothing factory at Baltimore and Eutaw streets, a shirt and overall factory in a building at Eagle and Payson streets, and a factory in Cumberland, Maryland, for the production of women's skirts, blouses, and suits. Additionally, a warehouse was maintained in Dusseldorf, Germany for the storage of toys.

In 1918 Mr. Epstein wrote an article in the *Old Bay Line* magazine (he loved to write articles). He called this one "Wartime Conditions Give Emphasis to Baltimore's Advantages as a Market."

Early in the summer of the following year the business was incorporated, and the name of the Baltimore Bargain House was changed to the American Wholesale Corporation. By this time Mr. Epstein was devoting himself principally to formulating the overall strategy of the business, spending a considerable amount of time on the question of how the business should relate to the economic outlook, and more particularly, whether the outlook for textile prices dictated an aggressive or a cautious policy with respect to the company's inventory.

Not only were most merchandise categories carried by the American Wholesale Corporation based on textiles, which made the movement of textile prices the key to successful merchandising, but in addition, the well being of the company's retail customers also depended heavily on cotton, since most of the company's sales came from customers located in the south, where the position of cotton had much to do with final demand for goods at the consumer level. Mr. Epstein took a keen interest

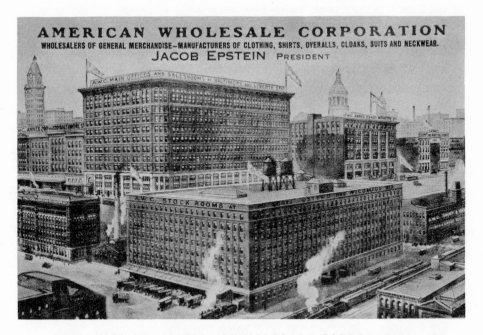

BUILDINGS OF AMERICAN WHOLESALE CORPORATION 1929

in these subjects and was unusually good at gauging and anticipating economic trends and developments that directly affected his company.

When the corporation was formed, the president and de facto chief executive officer was Jacob Epstein.

A. Ray Katz and Sidney Lansburgh, both sons-in-law, held the two vice presidential slots that the table of organization provided for. Mr. Epstein relied heavily on these two men, and no major policy decisions were made without the three consulting. Each son-in-law was responsible for merchandising about one half of the business, with A. Ray Katz specializing in piece goods and textile-based merchandise other than apparel, and with Sidney Lansburgh specializing in fashions and having responsibility for the financial management of the business.

Nathan Epstein served as secretary, as well as greeter and handshaker, and Abraham I. Weinberg was treasurer and credit manager.

In July 1919 a syndicate headed by Goldman, Sachs and Company and Lehman Brothers of New York arranged to purchase $2 million worth of 7 percent cumulative preferred stock of the American Wholesale Corporation.

The stock was offered at $100 a share and was quickly purchased by eager investors. The newspapers gave numerous details of the growth of the business. In 1900 the Baltimore Bargain House had gross sales of approximately $4 million and its profits were $270,000. By 1910 the sales had risen above $12 million and showed profits of $650,000. In 1915 the sales were almost $16 million and profits were $770,000. By 1918, when all types of merchandise were at a premium, the volume of business resulting from inflation and scarcity of goods due to World War I had swelled to over $25 million with profits of over $3 million.

By this time 50 percent of the sales of the business were accounted for by the catalog, which was mailed monthly to over 160,000 retailers. While the business was heavily concentrated in the South Atlantic area, it was mailed to all forty-eight states, and orders originated from each one. Now it was printed in color and generally ran to five hundred or six hundred pages. Mr. Epstein insisted that there be no exaggeration in describing any merchandise. He wanted to build confidence in the business and in the Epstein name.

To promote business the catalog always presented twelve items, called "the monthly dozen," which were loss leaders sold at cost. And in

January and July the company held semiannual sales that featured a loss leader for each department.

The other half of the company's business was accounted for by visits made by customers to the company's showroom at 200-208 West Baltimore Street. Free transportation to Baltimore was offered to any customer who purchased $1,000 worth of goods or more. When these customers arrived at company headquarters they were waited on by salesmen who not only sold merchandise and took care of orders but also arranged for hotel accommodations and entertainment. As previously stated, credit was extended generously and customers were given several months to pay their bills.

There were a number of other key executives, although none of these served as officers or held an officer's title. One such individual was Frederick Quellmatz, who played a key role in merchandising as a deputy to A. Ray Katz.

In 1920 Mr. Benjamin S. Hornstein (Benn) was brought into the business and given the responsibility of running the fashion departments under Mr. Lansburgh and also of managing the factories that manufactured fashion merchandise.

Among the buyers who retained a close affiliation with the founder was Guy Etting, who merchandised lace goods, ribbons and underwear. Mr. Epstein first met Etting when, during the early years of the Epstein marriage, the family had lived in the boarding house on Madison Avenue owned by Etting's mother. The friendship continued throughout the years.

Some old employees still remember a hard-boiled superintendent, Bill Dobson (not his real name), who was widely reputed to be anti-Semitic. He was often referred to, in the store, as "that ----." When some of Mr. Epstein's associates requested that their boss fire Dobson, he said, "Why should I do this and let him call me an S.O.B.? It is better that everybody else call *him* an S.O.B."

Mr. Epstein was always most courteous to his employees, greeting them warmly and simply. Many of his tastes in business were simple, too. He rarely left his office during the day, preferring to have a modest lunch brought to him there. Exceptions were made when outside philanthropic organizations sought his personal presence at campaign meetings. In such cases, business could not take precedence over charity.

In 1920 Mr. Epstein announced to his 1,600 employees the arrangement for a profit-sharing plan that would give them an opportunity to more than treble their investment in five years. The plan called for a participation by the employees of 5 percent of their weekly salary, the amount to be matched by the corporation for the benefit of the employee. Of the 1,600 people in the organization who were offered participation in the plan, more than 90 percent took advantage of it.

In 1921 one of the Baltimore banks, The Equitable Trust Company, placed an advertisement in the Baltimore *American*, the subject of which was the confidence of Jacob Epstein in his country. The lead caption was: "Jacob Epstein, a man with faith in the future of American business," and the advertisement read: "Jacob Epstein, president of American Wholesale Corporation (Baltimore Bargain House) yesterday backed up his confidence in the future of American business with an advertisement in the New York commercial papers headed: ˙WANTED: $5,000,000 OF DESIRABLE MERCHANDISE FOR SPOT CASH.˙ What business needs today more than anything else is a multitude of Jacob Epsteins, men with vision to see the future and the courage to act on their convictions."

In February 1923, *Credit* magazine published a story about Jacob Epstein. Here are extracts from it.

"There is no secret about the success of the American Wholesale Corporation," said Mr. Epstein; "when I started I made up my mind to build a business strictly on honor. Every article must be exactly as represented, or the goods could be returned. I have the distinction of being the first wholesaler in America who marked goods in plain figures, and then sold them strictly at one price."

When Mr. Epstein was asked how he had built up an organization at once so intricate in detail and comprehensive in scope, he said: "By employing better men and paying better wages than other houses. These things accomplish the best results." And it is well worth noting, as an outstanding feature of this very successful undertaking, that the men who were with Jacob Epstein twenty-five years ago are with him still.

At the present time, the customers of the American Wholesale Corporation are distributed through all the States of the Union.

There are, first, house customers who present themselves in

person in the marble entrance hall. Some of these house customers represent the original purchasers at the small Barre Street store, in the days when only the surrounding region was supplied.

Another class consists of old-established customers whose wants the American Wholesale Corporation has been supplying for years. A great many of these are in the Southeastern and Southern states, through which the first stage of expansion was developed. But there are also large and increasing numbers of customers West of the Mississippi River, and on the Pacific Coast, as well as in the Middle West and in New England.

In July, 1926, the *Baltimore Commercial Survey* had a story about Mr. Epstein, headed ''Business Built Strictly on Honor, Is Cause of Phenomenal Growth of the American Wholesale Corp.'' It reported that at that time the company had more than 40,000 customers. Ten thousand letters arrived daily, of which half were orders. It stated that every order was filled, if possible, on the day of receipt.

Of course, it is not possible in this book to include all the articles and stories that appeared both locally and nationally on the subject of Jacob Epstein's business success. They would fill another volume.

After the close of World War I Mr. Epstein began to be concerned about the future growth of his business. He noted the steady increase in a number of variety stores like Woolworth and Company, J. C. Penney, and other chain establishments. Merchandising policies had changed. The chain stores as well as many of the large retailers were buying their merchandise directly from manufacturers, and the part of the big wholesalers began to diminish. For several years Mr. Epstein had considered disposing of his business, and in 1928 he determined to wait no longer to make a sale. For this purpose he engaged Goldman Sachs, the large New York investment house, who was instructed to approach Butler Brothers of Chicago, but they were unable to make a deal. Mr. Epstein himself then took charge, and it was not long before the transaction was consummated, in November, 1929. Mr. F. S. Cunningham, president of Butler Brothers, issued the following statement: ''Butler Brothers, national distributors of general merchandise, and the American Wholesale Corporation of Baltimore, Maryland, will be merged at the close of this year. After January 1 next the Baltimore House will be operated as the

American Wholesale Corporation division of Butler Brothers.''

The only thing sold to Butler Brothers was the inventory. Cash and receivables were retained by the American General Corporation, the new name of the American Wholesale Corporation; the receivables being placed in the hands of Philip Hamburger, who, though it took him several years, did an outstanding job of bringing in the collectibles. The real estate remained in the hands of the American General Corporation and was rented for a term of ten years to Butler Brothers.

In a headline on the remarkable history of the business, the *Daily News Record* of December 9, 1929, headed its article "MERGER ENDS LONG CAREER IN BUSINESS OF JACOB EPSTEIN." It should have added one word after "long" — "honorable."

He Taught Us How To Give

One aspect of Jacob Epstein's many faceted life stands out above all others—his interest in the well-being of his fellowmen. Ever since the era of Enoch Pratt, Johns Hopkins, George Peabody and William Walters, Baltimore has had philanthropists, but none to rival Mr. Epstein in the catholicity of his generosity. He gave lavishly to both Jewish and non-Jewish causes in such abundance that he won the gratitude and respect of the general public.

His charitable instincts were, you might say, inherited. After he brought his parents to the United States in the 1880s, his mother would seek out poor families and present them with baskets of food. Every Passover her son would give her $50 for a new dress, but instead of spending the money on clothes she always gave it away to the poor.

Many of Mr. Epstein's gifts were made quietly to needy individuals, and he never divulged the fact that these people were obliged to accept charity. But when he gave to public institutions the contributions became public knowledge, and were recognized in the form of resolutions, letters of appreciation, and newspaper articles.

In March, 1905, the Board of the Hospital for Consumptives of Maryland (to be known later as Eudowood) sent him a copy of a resolution expressing thanks for a generous gift that enabled the hospital to care for a larger number of patients than theretofore and informing him that a new building erected with his funds would bear his name.

The following year we find him making a large gift to a Baltimore Talmud Torah.

In the fall of 1906 his generosity had become so widely known that he was appointed by Mayor E. Clay Timanus as a member of the Board of Supervisors of the City Charities. He served for two years.

By 1907 the section of the Baltimore Jewish community that came from Eastern Europe had founded several modest charitable institutions, including an orphan asylum, a Talmud Torah, and a home for the aged.

Early that year Mr. Epstein, perceiving the inadequacy of the building in which the aged were housed, purchased the headquarters of the Maryland College of Pharmacy, on Aisquith near Fayette Street, and presented it to the home, which changed its name to the Hebrew Friendship Friendly Inn and Aged Home.

Another group of Baltimore Jews, those whose ancestors had come from Western Europe—the "uptown" group, as they were called—had succeeded in forming, in 1906, a federation encompassing institutions that had been established individually by their predecessors: a hospital, an orphan asylum, a welfare society, a milk fund for mothers and babies. Observing the efficient operation of the new federation, Mr. Epstein presided over a mass-meeting of the Eastern European—the "downtown" group—at the Baltimore Theatre in 1907, urging them to take similar action.

The result was the organization of the United Hebrew Charities, which for twelve years directed the work of its individual agencies. At the outset Mr. Epstein was urged by many Jewish citizens, as well as by the newspapers, to accept the presidency of the new United Hebrew Charities, but he declined the honor, although he served on its Board of Directors throughout its existence. It may be noted that Mr. Epstein was already a member of the Board of the "uptown" group of agencies, known as the Federated Jewish Charities.

In July, 1909, the Baltimore *Sun* printed the following poem dedicated to Jacob Epstein by an unknown contributor.

> He hears the voice that asks for alms;
> The orphan's cry to him sounds close;
> His two hands have two open palms,
> Yet neither of the other knows.
>
> He gives not in the market place
> Whereby it may be seen of men;
> His giving has the gift of grace,
> He knows the Good Samaritan.
>
> He holds unto the Golden Rule
> And loves to do the good he can,
> Belonging to the good, old school,
> His simple creed, 'My Brother man.'

36

HEBREW HOME FOR AGED AND INCURABLES 1919

His heart is full of civic pride;
That heart is on his city set;
To all her interests, true and tried,
Nor have his pursestrings tightened yet.

His kindly nature shows in deeds;
A citizen who proved his claim,
Large-hearted in his city's needs—
Epstein, the world has learned thy name.

A few years later, in a letter to Mr. Epstein thanking him for a substantial check to the Deficiency Fund of the United Hebrew Charities, its secretary wrote: "You have once more demonstrated to us . . . that you are the prince of philanthropists."

One of his civic interests was Baltimore's Community Chest, known in those days as the Community Relief Fund. In December, 1914, Mr. Epstein wrote the editor of the Baltimore *Sun,* saying, in part:

I read with great pleasure . . . that you have passed the fifty-thousand dollar mark for the Community Relief Fund.

It shows that the people of Baltimore are charitable and all that is necessary is to have the case properly presented to them.

I think the idea to set aside December 25 as Self-Denial Day had good effect in helping to raise the fund. I, therefore, suggest that December 25 of every year to come be set aside as Self-Denial Day for the benefit of the poor.

From time to time Mr. Epstein would pay for personal messages in the newspapers, urging the people of Baltimore to contribute to worthy causes. One such message in the Baltimore *American* in 1915, requesting support for the Alliance of Charitable and Social Agencies, contained an Epstein exhortation that was widely quoted for many years: "Let every man give of his means, not of his meanness."

And in that same year, at the annual meeting of the United Hebrew Charities at the Maryland Theatre—attended by more than 1,200 people—he said:

Let us give more to charity and spend less on luxuries . . . Every year people are spending about $300,000,000 for moving pictures. We are spending $150,000,000 each year for candy. We are spending

$90,000,000 annually for chewing gum. We are spending a billion a year for automobiles . . . How much are we spending for charity? This is an extravagant age. The time has come for us to call a halt and take notice of our less fortunate fellows.

And he continued with this story:

Two friends were working in a western mining town. One was taken gravely ill. He sent for his friend and told him he was dying. Then he gave him $100 and a letter which was to be carried to his wife. He told his friend to give his wife what he wanted and to keep the rest. The friend gave the woman $5 and kept $95 for himself, saying that her husband wrote that was his last wish.

But the man's wife consulted her rabbi, who sent for the friend and told him that he was not treating the woman right. The friend then quoted the dying man's letter in which he instructed him to give the wife what he wanted and to keep the rest. The rabbi said: give her $95 and you keep $5 because the letter says that you are to give her what you want, and you want $95.

Mr. Epstein wound up telling his audience that they must feel it is their duty to help those who need their help.

His gifts to the St. Vincent De Paul Society, which distributed its funds to the Catholic poor, were lavish.

As chairman of a Red Cross committee, he took a full page advertisement in the Baltimore *American*: the declaration over his signature read: "We want everyone in Baltimore to do all they can for the Red Cross."

When the American Jewish Relief Committee was organized during World War I, Jacob Epstein started a custom that became practically his trade-mark in the field of Jewish philanthropy; he pledged 10 percent of all monies raised in Baltimore for sufferers from the war. When speaking at a campaign meeting of the Federated Jewish Charities, he repeated one of his favorite expressions: "Nobody ever went broke giving charity to the poor." Wherewith he doubled his contribution of the year before.

In 1919, in a Baltimore campaign for the Palestine Restoration Fund, he declared: "In the establishment of a Jewish homeland is seen the solution of the centuries-old Jewish problem." He predicted that Jews who had been ruined during the war by persecutions would be

offered a haven in Palestine. He then made a contribution twice as large as anyone else.

That same year a massive meeting was held at the Lyric Theatre to launch a half-million-dollar campaign for the Jewish War Relief Fund. As usual, Jacob Epstein's gift thrilled the community; he pledged $50,000.

Some of the inmates of the Friendly Inn and Aged Home were developing debilitating diseases that were forcing their removal to the City Hospital. To provide more individualized care for these unfortunates, the directors of the Friendly Inn secured a charter for a new organization, the Hebrew Home for Aged Incurables. And who provided the building for this home? Jacob Epstein, of course, who purchased a property at Baltimore and Chester streets and presented it to the directors of the Home for Incurables as a memorial to his parents.

In 1920 the Federated Jewish Charities and the United Hebrew Charities merged to form the Associated Jewish Charities, with A. Ray Katz as president of the new organization. At the first meeting Mr. Epstein called himself the father of the United Hebrew Charities and said he regarded the union with the Federated as a wedding upon which he must give the fullest expression of his paternal love and affection.

After a visit to the Holy Land in 1924 he sent out personal appeals to individuals to support the Karen Hayesod, the organization that purchased land for agricultural development. And he sent other personal letters asking for support for the United Palestine Appeal.

When Chaim Weitzmann, President of the World Zionist Organization, came to Baltimore in the fall of 1926, it was Jacob Epstein who chaired the committee for the reception.

He was always in demand as a speaker at Community Fund luncheons, for he always managed to come up with a new and effective punch line. One of his favorites, which he used to advantage at a number of such meetings, was that a good speech should be like a woman's dress, — long enough to cover the subject and short enough to be interesting. In 1926 he told the workers: "You should realize you are offering the public the best merchandise on the market. Our people have plenty of money to buy automobiles . . . but when you ask them to give to the poor, they seem to grow a little hard of hearing."

When he addressed the workers of the Community Fund campaign in

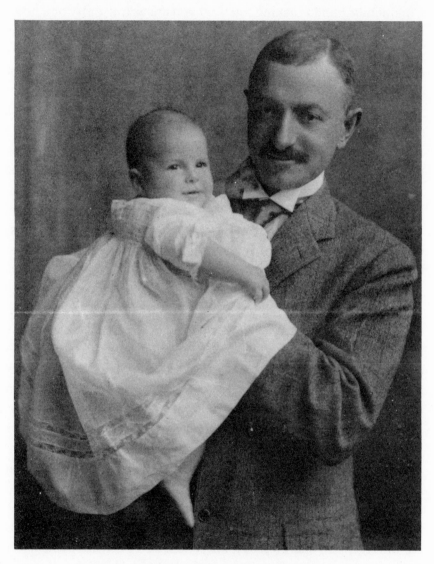

JACOB EPSTEIN WITH FIRST GRANDCHILD,
KAUFMAN RAY (KOFFY) KATZ

1927 he told them: "I went out to the Pimlico race track the other day and saw the people clamoring to get to the windows. You would have thought it was a bargain day. They take in more money out there in a day than the Community Fund is asking for. And you are asking only for a little more than a dollar for every person in Baltimore. It's a bargain you're selling."

Jacob Epstein continued his established rate of giving to Jewish causes. When in 1928 the United Jewish Appeal raised its quota for Baltimore to $750,000, he raised his contribution to $75,000.

In 1933, when he took his regular vacation abroad, he interviewed many refugees from Germany and was horrified at the barbarity of the Nazis. He reported his findings at a meeting at the Southern Hotel under the auspices of the American Jewish Congress. He was one of the first Baltimoreans to describe in detail the German atrocities, mentioning that "the Nazis are eliminating Jewish doctors, lawyers, judges, teachers, and other professional people who have been German citizens for years." He described the condition of Jews in Germany as being much worse than news reports indicated. He said, "the favorite pastime of the Nazis is to go to a Jewish house in the middle of the night and rob and plunder. If the Jews resist they are beaten and taken to the Nazi headquarters where a complaint is lodged against them that they are communists or socialists."

In the days of the depression Mr. Epstein met with Harry Greenstein, Joseph Sherbow, and Sidney Lansburgh. He put aside $10,000 for families in need. If that money was used up while Mr. Epstein was abroad, Harry Greenstein was to call on Sidney Lansburgh or Ray Katz for more. Mr. Epstein said that this was never to be disclosed, but it was known that more money was called for twice that year and at least once the following year. The money was to be used for any family in need and not according to any "old standards." The only condition Mr. Epstein made was that these gifts were to remain anonymous.

The Jews of Palestine continued to be one of Jacob Epstein's absorbing interests. He had given a modest sum as a "down-payment" for the establishment of a professorship at the Hebrew University in Jerusalem, and in 1934 he brought the figure up to $50,000 to endow a Chair of Hygiene and Bacteriology.

Much that he contributed was unknown to the public, and letters of appreciation are still occasionally unearthed, such as one from the Chair-

man of the European Executive Offices of the American Joint Distribution Committee. He wrote Mr. Epstein: "Through your initiative about 30,000 children [in Poland, Roumania, Latvia, and Lithuania] have up to now been fed."

In a 1936 letter to the *Jewish Times* he made "an appeal to everyone in the Jewish Community" and said: "The man who wants to be a good citizen must help his fellow-sufferers and feel that his pleasure cannot be real as long as someone else suffers through his indifference."

When Levindale celebrated its Golden Anniversary in 1940, Mr. Epstein recalled that at the age of twenty-six he had been one of a small group who formed the Hebrew Friendly Inn, the beginning of Levindale, and said: "We cleaned the streets of the poor. They were no longer degraded; they could be taken care of."

Those who remember the campaigns of the Associated Jewish Charities in the 1920s and thirties must recall with a sense of nostalgia the opening meetings held in the great ballroom on the top floor of the Southern Hotel. At these meetings, the initial "pitch" was made by the campaign chairman, and then came a long pause while the assembled hundreds waited for the big contributors to rise and announce their pledges. As the chairman's remarks came to a close all eyes turned on Jacob Epstein. He never hesitated for a moment. Rising from his seat at the head table he would say candidly, "I guess you are all waiting to learn what I am going to do. Well, I will give 10 percent of the total amount raised by everyone else. And now that you know what I am willing to give, I hope you will make it expensive for me." And then he would chuckle—a laugh like no one else's, out of the sides of his mouth, between his teeth—so infectious that the crowd would laugh with him and cheer and applaud.

The community never knew the extent of his philanthropy, but they had one clue, thanks to Uncle Sam. The Internal Revenue Department had special tax regulations for individuals who for a period of ten years or more contributed at least 90 percent of their taxable income to charitable institutions. The Internal Revenue records indicate that Mr. Epstein qualified for such specialized treatment, year after year. There was probably no other Baltimorean who fell into that category.

He encouraged other generous friends to share with him when he took

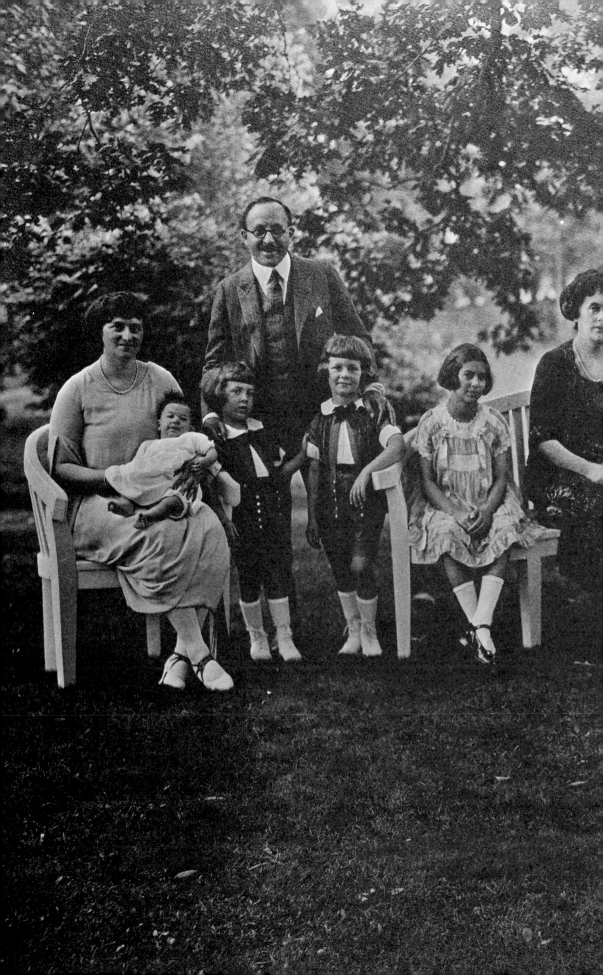

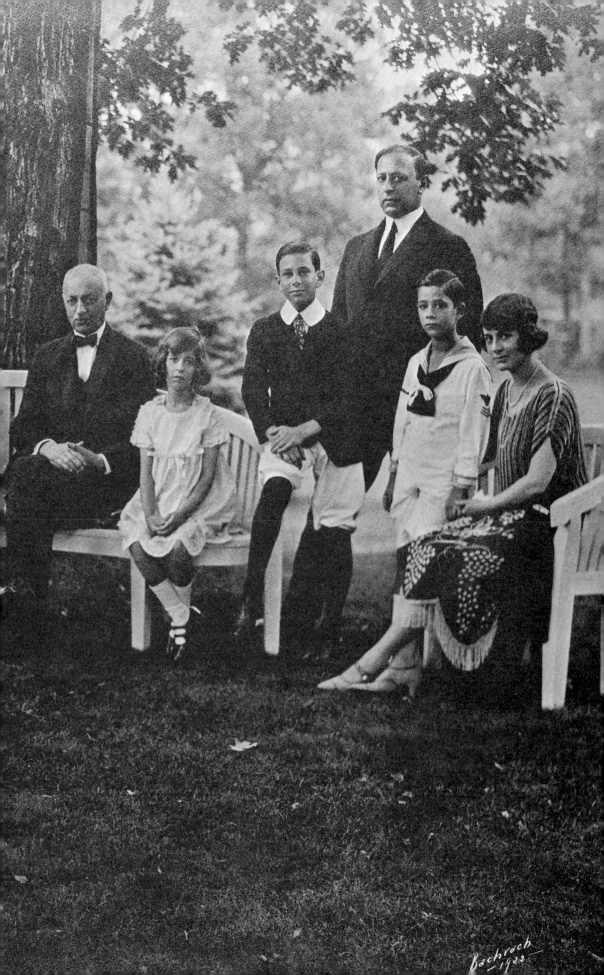

Bachrach 1923

1—MARIAN LANSBURGH

2—RICHARD LANSBURGH

3—ROBERT LANSBURGH

4—SIDNEY LANSBURGH

5—SIDNEY LANSBURGH, JR.

6—ELIZABETH LANSBURGH

7—"MA"

8—"PA"

9—HARRIET KATZ

10—KAUFMAN RAY KATZ

11—A. RAY KATZ

12—JACOB EPSTEIN KATZ

13—ETHEL KATZ

on a worthy project. An example of this is referred to in the establishment of Mount Pleasant, when a number of men erected cottages, which bore the names of their donors.

Two brothers, good friends of Jacob Epstein, frequently participated in bits of his private philanthropy. One day he called on the older brother and said, "William, there is a poor man I know who needs help. I want to raise two hundred and fifty dollars from each of four men and I wonder if you can give me the name of one man I can approach." His friend replied, "Jacob, I will be glad to give you two hundred and fifty dollars." "No, no, you do not understand," said Mr. Epstein. "I already have three men, you, your brother Julius, and myself. I am looking for a fourth man."

Sometimes men would come to his office to solicit for charity. As a rule they were first escorted in to see Ray Katz. He would listen to their story and offer them an amount of money. Then they were taken into Mr. Epstein's office, where Mr. Epstein, after hearing their plea, would offer either nothing at all or less than Ray Katz. When he was told that Ray Katz had given them a larger amount than Mr. Epstein suggested, so wouldn't Mr. Epstein at least do the same, Mr. Epstein would reply that Ray Katz had a wealthy father-in-law, whereas he himself was born into a very poor family, who for many years had to struggle to survive the wretchedness of life in Lithuania.

Not all his experiences at fund-raising were so easy, and at times he had to resort to more subtle methods. At one luncheon meeting he told this story: "The other day I approached a friend of mine who has made a good deal of money in the past few years, and I asked him for a check for several thousand dollars for the charity fund. 'Jacob' he said, 'there has been a lot of exaggeration about the profits I have made in my business. My expenses have been heavy. I have had some bad losses. The fact is, that I am not much better off financially than ten years ago. I cannot possibly afford to subscribe the amount you ask, but just because it is you, I will write a check for five hundred dollars.'

"'Joseph,' I answered, 'This is all very interesting; but I happen to be a director in one of the banks. The other day we held a meeting to discuss making loans to some of our customers. Among the applications was one from you. With it was a statement showing the condition of your business. All I have to say is that either you were lying then or you are lying now.'

47

I came away with the subscription I asked for."

Jacob Epstein's generosity has long been a legend, and the example he set inspired countless of his fellow-citizens to follow, as best they could, his precedent. Truly, as one of his friends said—a remark that has been repeated on numerous occasions—"he taught his city how to give."

Mount Pleasant

As we have seen, Jacob Epstein's charities were manifold. No worthy cause failed to elicit his support. But, as George Orwell put it in *Animal Fair* ''All animals are equal, but some are more equal than others,'' and there was one affliction that appeared to touch Mr. Epstein's nerve more sensitively than any other: the dreaded illness, tuberculosis.

For a number of years in the early 1900s he was a board member of the Hospital for the Consumptives of Maryland, later known as Eudowood. He donated a cottage to the hospital in 1905. But he recognized that there was one group of tuberculous people for whom Eudowood was not the ideal home for treatment or convalescence—the Orthodox Jews.

Many of Baltimore's poor Jews were living in squalid homes and working in nearly intolerable sweatshops; they and their families were vulnerable to the dread disease. Despite their physical handicap, most of them subsisted on strictly kosher food, which Eudowood was not equipped to serve. As a result, many sick Jews remained in their homes and refused outside treatment, which would have required them to eat ''trafe.''

Jacob Epstein was keenly aware of the desperate straits of these unfortunate families, and, as always, when he saw a potential solution, he acted. The formal action came on June 8, 1907, in the form of a letter to Dr. Jacob H. Hollander, president of the newly created Federated Jewish Charities of Baltimore. Here is what he wrote:

As I am about to leave for Europe, I desire to confirm my proposition in reference to the establishing of a hospital for Jewish Consumptives in the vicinity of Baltimore.

I will donate for this purpose a sum not exceeding thirty-five thousand dollars ($35,000.) on the following conditions:

You are to purchase, as soon as practicable, a suitable site and erect a hospital thereon, the site to cost about five thousand dollars ($5,000). The hospital to be erected thereon shall contain at least

ninety-five thousand five hundred (95,500) cubic feet of space, and shall have at least forty-seven (47) rooms, and shall have the capacity of accommodating at least twenty-four (24) patients at one time; also, four (4) rooms for office and nurses, and four (4) rooms for the help. Said hospital shall be so constructed that at least sixty patients can be accommodated at one time in the dining rooms, kitchens and administrative departments.

The amounts needed to carry on the construction of said hospital in accordance with the above conditions will be furnished at my office, as the same may be necessary.

The offer was gratefully accepted by the board of the Federated Jewish Charities, which adopted a resolution reading, in part:

. . . in accepting the offer, the Board desires to express its recognition of the humanity and generosity which prompted Mr. Epstein to place at the disposal of this Board the sum of $35,000 for building and equipping the Jewish Home for Consumptives, seeing also in his example an inspiration to this Board to do what lies in its power to make the institution a source of public good; and the Board recommends that the Committee on By-laws take cognizance of the Board's desire that Mr. Epstein's name be connected with the institution in some appropriate way.

It was the sense of the meeting that the proposed institution be conducted according to the Jewish dietary laws.

And thus was born the Jewish Home for Consumptives. For a number of weeks a committee consisting of three board members, Albert Brager, Louis Kann, and Benno Kohn, searched for a suitable site for the sanitorium. They finally selected a seventy-two acre tract of land on the Westminster Pike, about a mile beyond Reisterstown.

The voluminous details incident to the completion of the home were taken care of without serious problems arising. An architect, Charles Anderson, was chosen; a grove of one hundred trees (buttonwood, silver maple, Norway spruce) were planted at a cost of $75; electric lines were brought in and current furnished at 15¢ per kilowatt hour; a superintendent, Dr. Smirnow, was engaged at a rate of $1,200 a year. Dedication of the home took place on June 11, 1908, just before Mr. Epstein's departure on his annual European trip.

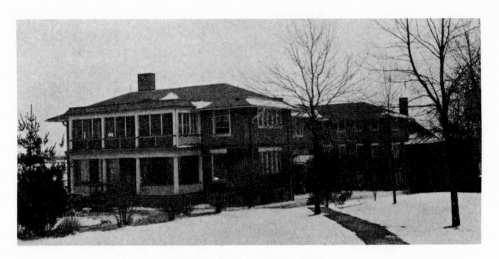

MOUNT PLEASANT c1910

The original hospital was built to house twenty-four patients, sixteen males and eight females; and in July the first group was admitted—not the maximum load (that would come later), but nine men and five women.

In the first year there was a rapid turnover, not only of patients but of superintendents as well. A good—and permanent—superintendent was hard to find. Dr. Smirnow was succeeded in 1909 by Dr. Merritt, at a salary of $800; in 1910 Merritt's successor was Dr. Graves (salary unknown); in 1911, came Dr. Louis Rubin, salary $1,000; in 1913 two in succession, first Dr. Meyer Friedman, to be followed by Dr. Jacob Cohen ($1200). Finally, in 1919, Dr. Albert Shrier took over the reins at a salary of $2,000, and under his supervision for some thrity years the institution was one of the best operated consumptive homes in the country.

For many years some of Baltimore's finest doctors volunteered their services. One of the most beloved was Dr. Samuel Wolman, who tried to visit the hospital daily and whose rapport with the patients was never surpassed.

At the outset Mr. Epstein made it plain that although the idea for the enterprise and the initial investment were his, he welcomed the participation of others who were stimulated by his ideas. As a result, contributions were made and additional cottages were erected by other generous patrons of the Federated Jewish Charities. Each cottage bore the donor's name. However, when it was discovered that one would-be patron unfortunately did not have the means to pay for his cottage, Mr. Epstein, who maintained a proprietary interest in the entire project, quietly paid the bill, allowing the man's name to adorn his building.

The records of patients admitted, with their length of treatment, were carefully maintained. The oldest patient was seventy-one; the youngest, seven. The longest stay was 662 days; the shortest, 1 day. All sorts of occupations were on the lists, which were headed by tailors and housewives, but there were also cigar makers, barbers, ragpickers, actors, and schochets, as well as school children.

Board meetings and committee meetings were held frequently, no less than once a month and sometimes two or three times during the month. Mr. Epstein arranged to attend practically every meeting. It was a rare occasion, except when he was abroad, that his name was not listed in the minutes. Records from a few of the minutes prove enlightening, or at

least entertaining.

The medical committee was authorized to engage nurses at a pay, if necessary, of $30 per month for same.

April 5, 1910—Dr. Harry Friedenwald announced that he had been informed that the hill on which the institution was built, or a neighboring hill, had been called Mt. Pleasant. On motion the name was adopted for the institution and the grounds committee was authorized to have·the name put on the front gate.

The committee on legislation, Mr. Simon, chairman, reported the appropriation by the legislature of $3,500 to the Jewish Home for Consumptives of Baltimore.

July, 1913—A contribution of $100 to the new fire truck at Reisterstown was authorized, provided a contribution of $50 recently paid by Mr. Epstein for a fire truck was not contributed for the same truck. If it was, then our contribution is to be $50.

November 3, 1914—Dr. Levin, who had substituted while Dr. Cohen was on vacation, was paid $30 for three weeks.

It was decided that the pigeon house be removed from its proximity to the building.

It was a long and difficult trip from the city to attend these meetings. Mr. Epstein eliminated this problem by providing an automobile for his board members and for the doctors so that the trip could be made in comfort, and with a minimum of delay.

A year or two after the institution had opened, it was found that there was a serious problem in securing work for patients who had fully recovered and were able again to make a contribution for their own welfare and that of their families. To stimulate investigation as to how such cases might most appropriately be helped, Mr. Epstein, with his accustomed generosity, contributed a substantial sum as the nucleus of a fund to be devoted to this purpose.

Again, early in the life of the institution, Mr. Epstein realized how difficult was the life of the wives and children of tuberculous patients when the breadwinner was no longer able to provide. Mr. Epstein came forward and offered a large sum for this purpose on an annual basis, stipulating wisely that he would give it only if matched sums were raised

53

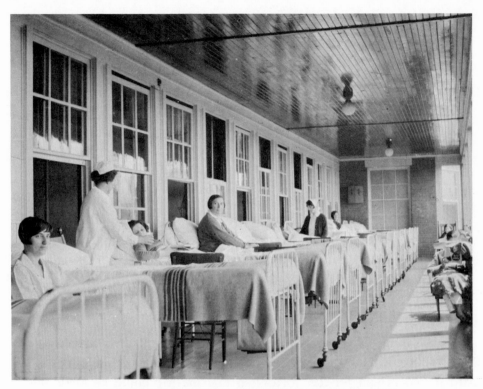

PATIENT DORMITORY MOUNT PLEASANT c1910

from other individuals. His challenge was met and the hoped-for help for the women and children materialized.

In 1914 a memorial grove was started, with trees planted in the names of friends of Mount Pleasant who had passed away. The first year fifty-two trees were planted, and the board was encouraged to make an annual practice of adding trees to the grove. Hundreds of families were anxious to memorialize their loved ones in this way, and as a result, through the years the memorial grove became one of the most beautiful parts of the entire institution.

For fifty years the impressive hospital on the Westminster Pike tended its ailing patients, helping to cure thousands of tuberculous Jews—yes, and non-Jews, too—who might not have survived without it.

However, as in so many branches of medicine, the method of treatment for tuberculosis changed radically over the years. The time came when it was determined that the location and long established treatment at Mount Pleasant were no longer viable. This did not mean that there were no more tuberculous patients but that the disease could best be controlled and treated with a full complement of medical services, rather than in an institution miles and miles away from any general hospital.

Accordingly, when Sinai Hospital erected its new building in Mount Washington in 1959, one building in the complex was set aside for tuberculous patients. The name Mount Pleasant was given to it and a striking likeness of Jacob Epstein done by Anna Dresser—a copy of Sir William Orpen's portrait at the Baltimore Museum of Art—was placed in its lobby. Much of the important equipment that had been used by the institution at Mount Pleasant was installed in the new building at Sinai.

Today tuberculosis is, for the most part, so controlled that parts of the Mount Pleasant building at the hospital are used for other types of cases. However, no one entering that building can fail to be reminded of the generosity of the man who made possible this most important development in the health care of Baltimore Jews.

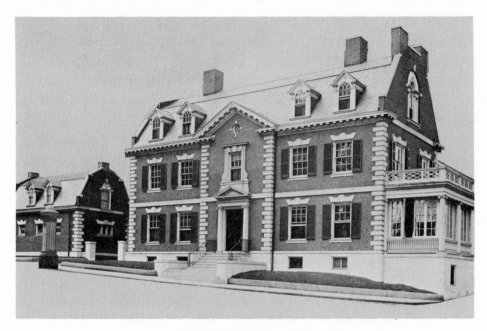

2532 EUTAW PLACE

In His Heyday

Jacob Epstein and Cardinal Gibbons were great friends. On many occasions they would take walks together, enjoying not only the exercise but the frank conversations of two men who were able to stimulate each other intellectually.

One day, when Cardinal Gibbons was eighty years old, Mr. Epstein, noticing that the Cardinal seemed melancholy, asked the reason. "Mr. Epstein," the Cardinal replied, "I have not been feeling at all well lately. I am afraid I am not long for this world." "Your Eminence," Mr. Epstein said, "I would not worry if I were you. The Lord knows a good investment when he sees one, and he is not going to call a gilt-edged bond like yourself before it reaches par."

He invited the Cardinal to visit him at the Baltimore Bargain House, and took him on a tour of the building. After an exhaustive inspection of the awesome enterprise, the Cardinal said, "You must have every type of merchandise in your store except coffins." Quickly Mr. Epstein replied, "That's the last thing I want to go into."

His fund of stories was legion—and always appropriate. In a special desk drawer, classified by subject, he kept typed copies of stories and jokes that he liked. Sometimes, at fund-raising meetings, people in the audience might see him pull out a small black notebook and occasionally write a few words in it. It may have. been a reminder of something he desired to say, or a new story he had just heard and did not want to forget.

He enjoyed telling about the rich man who did not give to charity but always said he would take care of that in his will. One day, when he was walking in the woods, a terrible storm arose. Looking around for shelter, he saw a hole in a tree and crawled in. The tree swelled from the heavy rain and the hole became so small that when the rain stopped, he could not climb out again. Since the tree was off the main road, the man became convinced that he would never escape and would die there. He began to

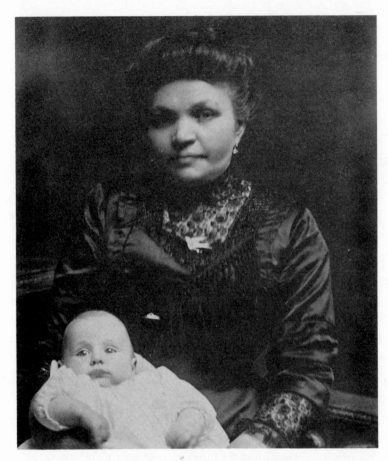

ROSE EPSTEIN AMRAM AND GRANDSON
FRANK L. BLUMBERG c1912

think of his past life and realized how foolish he had been in never giving anything to charity. The thought overwhelmed him. He felt so small that he fell out of the hole.

Mr. Epstein liked to tell at charity drives, too, the story about the animal kingdom. The lion as king of the beasts used to have to listen to the complaints of all his subjects. One day the hog came to him, complaining how badly he was treated. He pointed to the horse, well-fed and provided with a nice stable; the dog with a kennel and plenty of food; the cat, sheltered and fed in the house. The hog lamanted that nobody looked after him or cleaned him; he had to sleep in a filthy pigpen and root for his food in the mud and slime. "Yes," said the lion, "but all the animals you mention give service or pleasure during their lifetime." "But," said the hog, "you know I furnish pork chops and bacon." "That's quite true," replied the lion, "but we have to kill you before we can get anything out of you."

Mr. Epstein would chuckle when he told the story of the boy who was asked what he was going to study at school. "Oh," replied the boy, "I'm going to study to be a philanthropist. They are the only people who have any money nowadays."

On one of his visits to Cardinal Gibbons, the Cardinal mentioned that he heard that Bishop Murray of the Protestant Church had invited Mr. Epstein to attend his daughter's wedding and that he thought this was very nice of the bishop. "Yes, your Eminence," said Mr. Epstein, "That is more than you ever did for me."

When his daughters were young, Mr. Epstein used to own a "trap," a small open carriage. He enjoyed driving the girls behind a good horse, out through Druid Hill Park and up Park Heights Avenue; his daughter Ethel, when in her late 80s, still remembered those pleasant little jaunts. Later, when he was living on Eutaw Place, he purchased two Pierce Arrow automobiles, a limousine for winter and an open touring car for summer. But that did not prevent him from walking several miles daily. On clear winter days, he would set out on foot from his home, wearing—if the weather was not too chilly—a light weight topcoat; then after a while he would beckon to his chauffeur, Ben Hiss, who had followed him discreetly in the Pierce Arrow. The car would draw up to the curb and Mr. Epstein would climb in, discard the lightweight coat, and put on a heavier one. Then he would drive to his office.

Sometimes he would see acquaintances walking down Eutaw Place or standing on a corner, and he would pick them up and take them to their destinations. One acquaintance had a reputation of cadging from his friends "loans" that he would conveniently forget to repay. On one occasion this gentleman was waiting on a corner outside his home when Mr. Epstein drove by, stopped, and invited him in. After the car had proceeded a few blocks, the gentleman said, "Oh, I just remembered, I left my wallet on my dressing table. Could you lend me a dollar? I'll give it to you the next time I see you." Mr. Epstein called to his chauffeur: "Take Mr. back to the corner of Wilson Street. Then he can go in and get his wallet." It is not reported whether or not the man rejoined Mr. Epstein after he had been deposited in front of his apartment.

Occasionally Mr. Epstein would go out for a light meal in the early evening. A favorite eating place was the Kaiser Restaurant at the corner of Madison and North avenues. The only dish he ordered there was a cereal; as has been noted, he enjoyed the simplest foods. Nearly every day he stopped at Waller and Jones Drug Store (later known as Mannheimer's), just south of his home, for a cup of tea. It is reported that one day one of his grandsons was in Mannheimer's smoking a cigarette when he saw his grandfather approaching. Knowing of Mr. Epstein's harsh disapproval of such a habit, he fled to the rear of the store, where he took refuge in a telephone booth until Mr. Epstein had drunk his tea and departed.

In 1925, when the Ray Katzes were traveling in Europe, they visited Sulka's—one of Mr. Epstein's favorite shops—and purchased for him an elegant silk bathrobe, which they brought back to Baltimore in triumph. When they presented it to their father, he said, "Thank you, but I already have a bathrobe and it has a few more years left in it. Give the new robe to Koffy," (Kaufman R. Katz, his oldest grandchild) which they did.

Mr. Epstein enjoyed wearing fine clothes, but he was very thrifty and hated to throw away old shirts and socks. When he lived with the Lansburghs he would turn these accessories over to their housekeeper, Marian Hamilton, who was a skilled seamstress, and she would mend the aging apparel as best she could so that he might continue to wear it until it almost fell apart.

His pleasures, like so many of his other habits, were simple. For example, he enjoyed vaudeville shows. Nearly every Friday night he

NATHAN EPSTEIN 1924

IN HONG KONG 1925

would call for his brother, Nathan, who lived just a block down the street from him, and the two men would drive to the Maryland Theatre on Franklin Street, where the best vaudevillians performed. One of the headliners was frequently Ed Wynn, whom Mr. Epstein had met many years before in Philadelphia and whom he would often bring to 2532 for dinner. Wynn taught Ethel her first piece on the piano, written by him and called "Rag Doll."

Mr. Epstein would always buy an extra ticket for Ben Hiss so that the chauffeur could enjoy the show instead of waiting outside in the car.

In later years, as his grandchildren were growing up and vaudeville was on the wane, he would take a grandson to supper at the Southern Hotel (in the cafeteria, not the dining room) and then the two would go to a motion picture, usually at the Century Theatre on Lexington Street. He enjoyed musicals, and his favorite actress was Jeannette MacDonald. He was careful not to get in a draft; if he felt one, he would get up and go to another part of the theater, and to keep his head from becoming cold, he always wore a skull cap as he watched the show.

In due time the Katzes had three children, Koffy (Kaufman Ray Katz), Harriet, Buddy (Jacob Epstein Katz); the Lansburghs four, Libby (Elizabeth), Sidney (Sidney Lansburgh, Jr.), Robert and Richard. In the summer of 1924 Ray and Ethel Katz rented a fine old estate, Grey Rock, situated on Reisterstown Road not far from the Greenspring Valley Road. They were so taken with the charm of the place that they purchased it in 1925 and moved into it as a year-round residence in 1927. Mr. Epstein was not completely happy with the arrangement because he used to enjoy walking from his Eutaw Place home to the Phoenix Club, where he would meet friends, have a card game, and walk home again. In the wilds of Reisterstown Road this type of activity was impossible. However, Mr. and Mrs. Epstein moved in with the Katzes shortly thereafter. From then on 2532 Eutaw Place was vacant until it was sold in 1935.

Marian and Sidney Lansburgh's second home was in the 2300 block of Eutaw Place. In 1921 they purchased the property at 7200 Park Heights Avenue, a lovely house set in spacious grounds.

In 1932 Mr. Epstein left Grey Rock and moved to "7200." His method of moving probably came as a surprise to his family; returning from one of his seasonal trips to Europe, he merely issued directions,

"Send my luggage to 7200 Park Heights Avenue," and that was to be his residence for the rest of his life.

Mrs. Epstein preferred to remain at Grey Rock and stayed there for another ten years, until an apartment was rented for her on Labyrinth Road, where she lived with a nurse-companion, Mrs. Fred A. Kennedy, and her husband, remaining at that address until her death on May 7, 1950.

Like her husband, Mrs. Epstein ("Ma" to her family; Mr. Epstein was always "Pa") enjoyed good moving pictures. Accompanied by Mrs. Kennedy or her sister, Mollie Cahn, she would go to the Century, which used to be the handsomest theatre in the city, and sit in the first row, behind the huge organ. Each day, weather permitting, Hiss, the chauffeur, took Mrs. Epstein for a one-hour drive in whichever car was in service.

Every year Mr. Epstein took two trips to Europe, one in summer and one in winter. His arrivals and departures were state occasions. All the members of the Katz and Lansburgh families would assemble in New York to see "Pa" off or to welcome "Pa" home. There was virtually no deviation from this procedure; it was as much a ritual as attending synagogue services on the Day of Atonement.

Most of the vacations were spent in France, principally Paris and Nice in winter, or Paris and Vichy in the summer, or on one or two occasions at Plombier-les-Bains, a health resort in the Vosges Mountains, or in Algiers. Mr. Epstein was seldom lonely, for he met attractive men and women who became good friends, and a number of whom he saw year after year.

Yet he was devoted to his family, even though the relationships were unusually formal. At home he often made a fuss over his grandchildren, spending as much time as was possible with them. When he was abroad — and this might be for as long as six months or more each year — the extent of his communications usually ran to frequent postcards to different members of the family, reading simply "Love and kisses from Pa." The address labels for these were always prepared before he left by his secretary, Mr. Henry Manko, and were then affixed to the postcards.

In 1925 he decided to take a world cruise on the S.S. *Belgenland* of the Red Star line, with a friend, David S. Kaufman, Envoy Extraordinary and Minister Plenipotentiary of the United States to Siam and later to Bolivia. A few exotic photographs taken in the Far East show him in somewhat

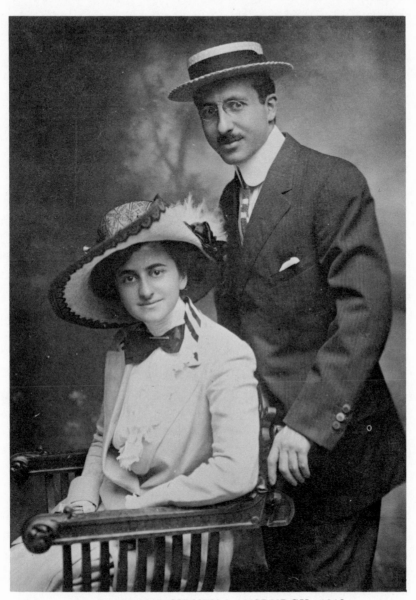

MARIAN AND SIDNEY LANSBURGH c1913

unusual situations. In one, he is riding in a sort of open palanquin in Peking, supported on the shoulders of two husky Chinese coolies. In another, sent from Hong Kong, he is seen being drawn in a sort of rickshaw by a local resident. Still another, taken in India, shows him standing beside some natives, their water buffalo harnessed to a cart. In each place, he was a model of sartorial formality. In his Peking palanquin, he is wearing a Chesterfield coat, gloves, and a Homburg hat. In India, where it must have been boiling, he is in a lightweight suit, a pith helmet on his head. Upon returning from this trip Mr. Epstein told fascinating stories about his experiences but said "never again" because of the suffering he saw. The poverty and sickness were overwhelming.

His aversion to written loquacity bordered on the extreme. In 1935, when Franklin D. Roosevelt was President, certain important new tax regulations were formulated, affecting the family's financial situation. Jacob Epstein was in Europe at the time, and his sons-in-law thought it necessary to send him a very long cablegram outlining the new tax laws and proposing a certain method of taking care of their father-in-law's financial problems. They asked him to let them know immediately if their plan of action satisfied him. In response to this detailed explanation and proposal, they received a cable reply; it read simply "Yes." When Mr. Epstein returned home they asked him why he did not add a little bit to his cable. "At least," they said, "you could have signed your name." "Why should I?" said Mr. Epstein. "My cablegram came from Nice and you knew I was staying there. You could not have received this sort of cablegram from anyone else. It would have been extravagant to add another word."

For many years his headquarters in Paris was the Claridge Hotel. One day the manager of the Claridge complained to him about his terrible indigestion. Mr. Epstein offered his favorite remedy—eat plenty of prunes. The manager followed his prescription and soon felt so much better that he told Mr. Epstein the prunes had saved his life. Ever afterward when Mr. Epstein went to the Claridge, he was given the best room in the house.

However he never wanted the best room in the hotel. The best rooms faced the street, and Paris was a very noisy city, so Mr. Epstein always insisted on a small room in the court, where it was quiet and no disturbing

ETHEL AND A. RAY KATZ c 1934

sounds would interfere with his night's rest. Eventually he found the Claridge too stylish for his tastes, and he shifted to the Royal Monceau, a smaller, more modest establishment. Arrangements for his stay at the latter hotel were usually made by Joseph Tabbagh, whose personal travel service was well known to many Baltimoreans.

Mr. Tabbagh could never get over the fact that Mr. Epstein's arrival at the Royal Monceau was always known in advance by the poor Jews of Paris. Tabbagh recalls that they would be waiting for Jacob Epstein outside his hotel or near his steamship office, or on Friday nights at Flambaum's Kosher Restaurant. He would greet them all graciously and see that they did not leave empty-handed. And he always managed to pay a visit to the Marais section, near the oldest synagogue in the city, to talk to and help the poor members of the community there.

In Baltimore Mr. Epstein had a few close friends, among them Ben Elliott, Joseph Katz, Martin Lehmayer and Louis Blaustein. He would frequently go to the Phoenix Club for supper, after which his friends would be waiting to play pinochle with him. He preferred pinochle to any other card game, though after he moved in with Marian and Sidney Lansburgh he became interested in bridge. Irma Lansburgh, Sidney's sister, was one of his regular partners; Mrs. Abram Eisenberg (Helen) also played, as did Jesse Heineman, who was an exceptional bridge player. There were never any stakes at those games; no money changed hands. Precisely at eleven o'clock the gathering dispersed. That was Mr. Epstein's bed time. It did not matter whether it was in the middle of the hand or the middle of the game; eleven o'clock was the curfew hour.

When he lived with Sidney and Marian Lansburgh, meals were always arranged—and timed—to conform to his requirements. He was always a participant at Sunday lunches and at Thursday night suppers. At the lunches he always brought each Katz and Lansburgh grandchild a half-pound box of candy. Those lunches were scheduled for 1:30, yet Mr. Epstein was invariably late, sitting down at about 1:45. His daughter prepared special meals for him. His regular luncheon consisted of boiled chicken and hearts of lettuce without salt. (He called the lettuce "honeymoon salad"—lettuce alone with no dressing.) At Sunday lunch he always dominated the conversation with interesting stories, comments, and observations. If someone at the table were to start a side conversation

while he was talking he would say, "You (naming the individual) can hear this too." After about thirty to forty-five minutes at the table he would say, "Folks, you'll have to excuse me now." Then he would retire to his room and take a nap.

He insisted that the families always remain close, so the lunches included his son-in-law's mother, Mrs. Rebecca Lansburgh, and her three daughters. In fact, he was unusually solicitous of Mrs. Lansburgh; he felt that the apartment in which she had been living was not good enough, and he was instrumental in moving the Lansburgh ladies to a more spacious apartment on Mount Royal Avenue and Lake Drive.

Mr. Epstein had a formula that he used regularly for breaking up any disputes that might start between various members of the family; he asked the question, "When's Purim?" Since it occurs on a different date each year in terms of the European, as distinguished from the Hebrew, calendar, this invariably developed a new discussion, which turned the conversation away from the subject being argued about.

He always took a special interest in any other immigrants from his home town, Tauroggen. When he was a boy there he had a good friend named Sol Levitan. In 1881 Levitan followed Jacob Epstein to Baltimore. In that year Mr. Epstein had opened his first small store, which greatly impressed Levitan when the two friends met. Mr. Epstein told Sol Levitan that the best start a young man could make was to set out as a peddler. Levitan followed his advice, but instead of remaining in the Maryland area, was guided by Horace Greeley's well known admonition, "Go west, young man," and traveled to Wisconsin. His life story is told entertainingly in a book called "No Peddlers Allowed," which relates how he rose from the drudgery of peddling to become president of a bank and eventually treasurer of the state of Wisconsin. Through the years he enjoyed his relationship with Mr. Epstein, writing him to tell him of his success and in later years visiting him in Baltimore.

In one 1923 letter he said, "Your letter takes me back to the days when we both were poor boys in Tauroggen. Wealthy boys would have nothing to do with us, and it takes me back to 1881 when we both were peddling with our bundles made of black oilcloth. [Mr. Epstein had opened his first store when Levitan came to him in Baltimore] I have seen your statement that you have made many millions. It seems as if

you have performed a miracle I hear of you through the university professors — of your wisdom and your kindness. I am proud to have been born in the same town that you were.''

On only one point did the two successful men differ. Sol Levitan was a strong supporter of Robert La Follette for the presidency in 1924, while Jacob Epstein, a life-long Republican, distrusted La Follette, who leaned toward socialism. So strongly did he feel on this point that he took a full-page advertisement in a Baltimore newspaper to urge the readers to vote against La Follette.

Many Jewish newcomers to Baltimore used to make the first order of business a call on Jacob Epstein for advice. Among them was an acquaintance from Tauroggen who followed Mr. Epstein to Baltimore some years later. He had one of those unpronounceable names that immigration officials found impossible to spell and that resulted in the bestowal of a name far from the original. This gentleman told Mr. Epstein that he was anxious to go into the shirt business, and Mr. Epstein told him, "If you are going into the shirt business, you must have a good Jewish name." He looked at the man, a big ruddy-cheeked fellow, and said, "With a complexion like yours, you ought to take the name of Rosenbloom." The gentleman, who thereupon became Sol Rosenbloom, developed one of the largest work-shirt businesses in the United States.

Mr. Epstein always lent a ready ear to anyone in trouble. He set an unknown number of people up in business throughout the middle Atlantic region by granting them liberal credit terms. Some, like the Spector family of Philadelphia, who developed the highly successful Blum Store there, were among the recipients of Mr. Epstein's generosity. On one occasion he learned of a young man, an honor graduate of The Johns Hopkins University, who had been refused admission to The Johns Hopkins Medical School. Mr. Epstein thought that the only reason for the denial was the young man's religious affiliation, and he used his persuasive powers to have the Medical School reverse the decision, which it did. Today, this man is one of the most highly respected physicians in Baltimore.

A respected officer of the United Hebrew Charities who had a small apparel business was in desperate need of cash, and Jacob Epstein quietly, as was his custom, loaned him $10,000. Not long after the loan had been

made, the man died suddenly. Mr. Epstein dismissed the incident from his mind, making no effort to recover his loss. As it happened, the unfortunate man had three remarkable young sons, who made up their minds that they would do everything possible to repay their father's benefactor; they did not cease their efforts until the full amount of the debt had been liquidated. One of the sons has said that the happiest day of his life was the day he was able to give Mr. Epstein the final payment against the magnanimous loan made many years before.

Mr. Epstein's generosity was at times tempered with judgment. An old acquaintance, whose personal habits were well known to Mr. Epstein, approached him one day and asked him for $300. Somewhat to Mr. Epstein's surprise, the loan was quickly repaid. A little later the gentleman asked for a second loan in the same amount. Again Mr. Epstein advanced the money, and again the loan was soon repaid. When the man approached Mr. Epstein a third time for the same amount, he was politely turned down. "But you have loaned me this amount twice before, and each time I have paid you back," he protested. "That's right," replied Mr. Epstein. "You fooled me twice, and I don't want to take a chance the third time."

The Jewish Tribune of Chicago, a well-known weekly paper, conceived the idea of a voting contest to determine who were the fifty outstanding Jews of the world. When the ballots had been counted, Jacob Epstein's name appeared on the list.

"PA" ESCORTING HIS DAUGHTERS, PROBABLY IN EUROPE. c 1904.

The Good Citizen

Jacob Epstein traveled widely. He spent months at a time in France; he had strong attachments to Palestine; one year he toured the world. But Baltimore was his home, and he did everything in his power to make it a city to be proud of. Always uppermost in his mind was the conviction that Baltimore's responsible citizens had a duty to their community; and certainly, Baltimore has had no more responsible citizen than Jacob Epstein.

His civic interests in Baltimore, from the time he established residence through 1903, were largely unrecorded, though a letter of appreciation from the Board of Fire Commissioners was received as early as 1899.

Mr. Epstein played a significant role at the time of the great fire of February, 1904, when the heart of the Baltimore business district was destroyed. The flames reached the area of Baltimore and Liberty streets, directly across from the Baltimore Bargain House. Sparks fell in profusion on the roof of the building, but alert employees extinguished them before severe damage was done.

During the devastating fire he was most solicitous of the firefighters and their horses. The weary men were brought into the building and refreshed with food and coffee, while water was provided for the thirsty horses.

Again his generosity was gratefully acknowledged, this time by a letter from the Fourth Regiment of Infantry of the Maryland National Guard, who had assisted the fire department in fighting the conflagration.

Among the casualties of the disaster were the city's newspapers, whose plants were demolished. Mr. Epstein immediately made available to one of them, the Baltimore *Herald*, a large portion of the first floor of the Fayette Street side of his building, though he badly needed the room. The newspaper, which had intended to use the space for ninety days, remained there for eight months.

Mr. Epstein later served as a member of the Burnt District Commission, an advisory body that put forward recommendations for rebuilding the destroyed area.

For a long time Mr. Epstein had been convinced that the Republican Party was best for the growth of his city and the welfare of the country. The Republicans who controlled Baltimore's politics were aware of this, and they soon made use of his ability and his growing popularity. In 1904 Mayor E. Clay Timanus formed an executive committee of fifteen able citizens to advise him about improving the city, with well-paved streets, new schools, and annex developments. Mr. Epstein was made vice-president of this group.

His popularity was growing so rapidly that in a newspaper dispatch the following November it was reported that he would probably be named the next postmaster of Baltimore. This plum did not fall into his lap, but there is no knowledge as to whether the position was offered him and refused, or whether an active politician cornered it.

On October 9, 1906, Mr. Epstein was named to the board of supervisors of the city charities, a position he held for two years. The following year Governor Edwin Warfield appointed him a member of the board of the Hospital for the Consumptives of Maryland (later known as Eudowood).

In 1907 he took an active part in advocating the election to Congress of Frank Wachter, the Republican candidate. At issue was the "Poe Amendment," which aimed to disenfranchise anyone who could not read and understand the questions on ballots. The adoption of such an amendment would have made non-voters out of a large proportion of white foreign-born citizens, as well as most of the black population. Wachter campaigned for the defeat of the amendment; Mr. Epstein, as one of his most ardent backers, was delighted when the "good guys" won.

In 1909 the Metropolitan Opera Company offered to perform in Baltimore if it were guaranteed the sum of $100,000. This was a formidable amount for Baltimore to consider, but Mr. Epstein thought the opera would enhance Baltimore's prestige in cultural circles. Though not personally interested in most forms of music, he led the subscription list with a guarantee of $10,000.

Mr. Epstein observed that Maryland had very few large companies,

except for local ones, which were incorporated in the state. On the other hand, he noted that New Jersey was obtaining tremendous revenues from the franchise tax on corporations. The Maryland franchise tax was very high; similar taxes in New Jersey were very low.

Accordingly, he urged the state legislature to change the Maryland corporate tax law and reduce its franchise taxes, an action he was convinced would attract many companies to incorporate in Maryland. For three years he worked at the problem unaided; finally, with a boost from Robert Crain, another leading citizen, his proposal was adopted by the legislators. The result was an overwhelming increase in the number of companies incorporating in the state of Maryland, and a fourfold increase in the state's revenues from this source.

At this time a local aviation committee was formed to arrange for a great aviation meet to be held in Baltimore in November, 1910. Mr. Epstein was a member of that committee, serving not only because he was a staunch supporter of aviation but also because he knew the meet would be a fine advertisement for the city of Baltimore. For the winner of a contest among international participants a substantial cash prize was offered—donated by Mr. Epstein.

Never did the city have a bigger booster, and the public was aware of it. For example, in December, 1910, the following letter appeared in the Baltimore *News:* "How would Jacob Epstein do for Mayor? What the City Hall wants and needs is a businessman. He made good at his own business. Why could he not for the city?" And on December 17, 1910, in a character study of possible mayoral candidates the paper wrote, in part:

This open letter in the *News* Mail Bag, printed last Wednesday, indicates how the people are thinking on the mayoralty situation. To the question "What's the matter with Jacob Epstein for Mayor?" the answer would probably come from a great many people that there is nothing the matter with him. As "Unaffiliated Voter" says, he has "made good." Hence, Epstein for Mayor appeals to many citizens.

Mr. Epstein's devotion to Cardinal Gibbons is outlined elsewhere in this book. And when, in May, 1911, there was a special celebration in honor of Gibbons' twenty-fifth anniversary as a cardinal and fiftieth anniversary as a priest, Mr. Epstein was on the hand-picked committee to arrange the proper festivities.

75

That same year the new mayor of Baltimore, James H. Preston, decided to form an advisory committee of prominent businessmen to help him with the city's most perplexing problems. Mr. Epstein was asked to serve as a member of this blue ribbon group, and he was the first man to accept the mayor's invitation.

In 1913 Baltimore was a good baseball town but had no major league team. A group of zealous Baltimoreans, along with men in other large cities that craved, but were denied, big league baseball, decided to organize a third major league, to be known as the Federal League. Mr. Epstein was an ardent and active supporter of the Federal League team in Baltimore, participating in a $150,000 stock issue. Alas, its life was a short and unhappy one, and even men like Jacob Epstein could not prevent its expiration within two years of its birth.

During this period The Johns Hopkins University was operating in cramped quarters at Eutaw and Monument streets. It was clear that if the university were to expand, it would require grounds and buildings for enlarged engineering, science, and research activities. When the Homewood site was picked for the future home of the university, one of the biggest boosters was a man who had never even completed a high school education, Jacob Epstein, and he was both a giver and a fund-raiser for Hopkins at Homewood.

After the Federal Reserve Banking System had been established, Mr. Epstein became a strong advocate of the selection of Baltimore as the site for the Bank in District #5. When the announcement came that Richmond had been chosen for the bank, Mr. Epstein addressed a mass meeting of several thousand Baltimoreans, calling the choice "strictly political." But his protests, and those of all the other indignant people of the city and state who tried to reverse the decision, were of no avail.

The celebration of the centennial of the writing of the "Star Spangled Banner" occurred in 1914, and Jacob Epstein was one of a five-man executive committee that arranged for the observation of the anniversary in Baltimore.

Once more he was urged to run for office—for Congress, or for Mayor of Baltimore. In June, 1914, in the Baltimore *American's* People's Letter Box, a contributor recommended that Jacob Epstein be nominated for Congress, representing Baltimore. And later that year, the

Baltimore *Star* reported, regarding candidates for Congress:

Included in the Fourth District list of possibilities Jacob Epstein The business men who would undertake to urge Mr. Epstein to be a candidate say his intelligence and business acumen and his political views would make him an ideal candidate for Congress from a district where manufacturing plants are so numerous. The argument is also made that Mr. Epstein would be loyally supported by the employees of business concerns, who through their salaries are as vitally affected by the tariff and business conditions as are the employers.

As far as the Republican organization leaders are concerned it is understood they will gladly support Mr. Epstein. . . .

The *Sun* wanted him to seek the mayoralty.

Jacob Epstein is being urged by many of his friends and by party people as the right man for the Republicans to nominate next spring for Mayor. Mr. Epstein is said to have listened politely to all that has been said, but not to have indicated whether he would consider the matter seriously. Many close to him say he will not be a candidate.

A July, 1914, editorial said that ''there is hardly much doubt that Mr. Epstein as a mayoralty candidate on any ticket would make a powerful appeal to many people.'' Editorials from morning and evening papers had the following to say:

If Mr. Epstein should be elected Mayor and should build up the city as much as he has his own business, we don't believe even Democrats would weep very much over such a ''Republican'' administration.

It will be a happy day for Baltimore, and for all American cities, when suggestions of men like Jacob Epstein for Mayor come along as a matter of course.

Early in 1915 Congress laid before President Wilson a bill that would have severely restricted immigrant Americans by means of a literacy test. A tremendous mass meeting protesting the bill was held at the Victoria Theatre. Mr. Epstein was one of the organizers of the meeting. Among his staunchest supporters was Cardinal Gibbons, who expressed in a letter to his good friend the hope that the president would veto the bill. He wrote, in part:

The advocates of this measure claim that its application to those seeking a home within our country will prevent the influx of a large number of undesirable, prospective citizens, who though unable to read or write our language, may be fairly well educated in their own; and at least may possess health, strength, virtue, good sense, business ability, and a desire to succeed with high honor.

As we glance through the pages of the past the futility of such a test becomes apparent. Historians tell us that Charlemagne was unable to read or write, yet by his patronage he attracted scholars to his court, fostered education, and himself became the Ruler of the mighty Roman Empire.

If this literacy test had been applied in the 17th century, some of those who came over to Plymouth on the *Mayflower,* and to Maryland on the *Ark* and *Dove*, would have been politely informed that they were undesirable persons and positively requested to return to the shores whence they came.

What would this country have amounted to as a nation had its founders immediately after the Revolution closed its portals to honest but illiterate immigration? Many of the Nation's greatest men in every field of service were immigrants or the sons of immigrants. President Wilson did, in fact, veto the bill.

Mr. Epstein was always ready with a good story or an analogy to drive home a point. In 1915, when he was asked to be the speaker at a City Club luncheon he said: "To fulfill his duty properly as a citizen, a man must sacrifice time and money when called upon. . . All should work together. A good band playing in unison furnishes excellent music, but if each instrument is placed in a separate apartment there will be no harmony."

In mid-1916 Baltimore was heartened by the announcement of plans for a new $1 million hotel to be erected at Baltimore, Howard, and German (now Redwood) streets by the Baltimore Hotel Company, Jacob Epstein, president. All was proceeding smoothly until, a few months later, the United States entered World War I, and the project had to be scrapped, never to emerge again.

Nineteen Hundred Sixteen saw a swelling effort to enact a prohibition amendment, a move opposed by many leading Baltimoreans, who placed

advertisements in the papers signed "Citizens of Baltimore against Prohibition." High on the list of those responsible for the announcement was Jacob Epstein.

At that time there was a strong move to extend the limits of Baltimore City and annex a portion of the adjacent areas of Baltimore and Anne Arundel counties. Mr. Epstein was a founder of the Greater Baltimore Extension League, and he offered, without charge, the first floor of a Baltimore Street property he owned as headquarters for the league. As might have been expected, the largest contribution to the new organization came from him. He was pressed to accept the nomination as treasurer and chairman of the finance committee, but he declined the honor.

Frequently Mr. Epstein was asked to express his views about Baltimore in publications. In his writings he never failed to promote the welfare of the city. For example, during World War I, when the *Old Bay Line* magazine solicited an article from him, he used the title "Wartime Conditions Give Emphasis to Baltimore's Advantage as a Market."

Early in 1919 he paid for the following letter that appeared in the Baltimore *American*:

To General Pershing and the Champions from our city:

America has fought for no selfish conquest or sordid advantage.

To preserve her own liberties, to maintain her highest humanitarian ideals, to help make the world a decent place to live in, our young men have gone to war that has ended autocracy.

We wish to convey to the boys from our city who have represented us in this great war an expression of highest appreciation.

We have been in full sympathy with their efforts and will participate in all provisions which are made for their comfort in their hearty welcome home.

That fall Mayor William F. Broening appointed Epstein to the Board of Supervisors of City Charities, a position for which he was eminently qualified.

Soon afterward a pictorial sketch of Jacob Epstein headed "We have with Us Today" appeared in the Baltimore *American*. It touched on several of the reasons why he was so popular in the city. In cartoon form it stresses his civic mindedness, his generosity, and hints at his sly humor. The picture is reproduced in this book.

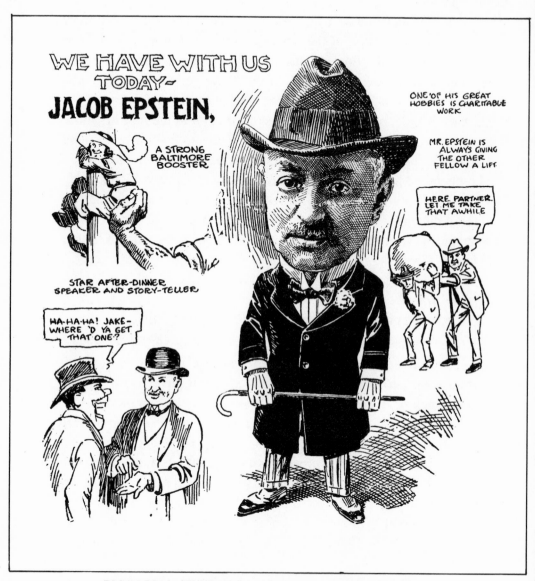

PICTORIAL SKETCH BALTIMORE AMERICAN 1920

In July, 1920, when the mayor decided that the city had to spend about $50 million for public improvements in the development of its port, he formed the Public Improvement Commission, composed of prominent citizens to study the city's needs and make recommendations. In announcing his appointment of Jacob Epstein to the commission, the mayor stated that Mr. Epstein had been selected by reason of his experience as a businessman and the interest that he had repeatedly shown in civic matters. Mr. Epstein justified the appointment by a thorough study of the potential use for the funds the mayor wanted. As a result of these studies, an improved method of developing the city's water supply was put into effect, and a critical study of Baltimore's school buildings resulted in the abandonment of some of the oldest, most dilapidated schools and their replacement by other buildings.

Mr. Epstein's interest in the improvements of the city were far-reaching. His scrapbooks show a keen interest in the city's new garbage system, in street paving, in the police and fire departments, in the development of park lands, in the city's piers, in portable schools.

Mr. Epstein was keenly aware of the enormous amount of money the city was planning to spend. Whereas other members of the Public Improvement Commission would have liked to select an engineer or an architect and give him full charge of whatever improvements were to be made, Mr. Epstein always insisted on getting alternate bids for whatever work needed to be done. If his views had not prevailed, the city would have been obliged to spend many more millions of dollars than was actually the case, and he must be given credit for saving huge sums of money in construction costs.

In 1922 Mr. Epstein took vigorous exception to a pay rate measure introduced in the Baltimore City Council that would probably have increased by many millions of dollars the cost of construction of new schools and other municipal buildings. Mayor Broening thought that the rates for carpenters and others who worked on these buildings should be set by the city, whereas Mr. Epstein and his followers were sure that this would mean the use of only union workmen at union rates and that non-union workers would be excluded. He fought the measure on the basis of the cost to the city. Eventually the City Council was convinced of the validity of Mr. Epstein's argument and supported him in its decision.

In 1922 the ballot contained a proposal for the city to borrow $15 million to pay for new schools with improved recreational facilities. That was a lot of money in those days, but Mr. Epstein, appalled by the many ancient, inefficient, and unsafe school buildings still in use, supported the bill vigorously, and it was approved by a 5 to 1 vote.

There were times when Mr. Epstein would take issue with people who were critical of the Public Improvement Commission. One of the old opponents of the old P.I.C. was Mrs. Marie Bauernschmidt, secretary of the Public School Association, who worried that some of the buildings that had been erected during the early 1920s were unsafe and who urged their correction. She was supported by a Grand Jury report to the effect that the P.I.C. had been negligent in permitting some inferior materials to be used on one particular school, and the matter was taken to court. While it was found that the building was faulty in construction, the P.I.C. was absolved from blame.

On January 9, 1927, it was reported that the Public Improvement Commission would soon close its program. It had been allocated $66 million since 1920, and by January, 1927, $54 million had been spent. Among its accomplishments was the erection of five new high schools and the construction of the Loch Raven Dam and Reservoir.

On January 2, 1927, Mr. Epstein sent a letter to Mayor Howard W. Jackson endorsing a proposed new 10-million-dollar school loan and at the same time indicating that at the end of the year he would retire as a member of the Public Improvement Commission. Of the work of the commission he wrote:

In November 1920, the P.I.C. started its work. The city had at that time about 155 schools, not one of which was of fireproof construction, with exception of the old Baltimore City College and a part of the Polytechnic Institute. The P.I.C. has now completed 27 schools, everyone of which is of fireproof construction and there remains to be finished three schools which also will be of fireproof construction. The schools which the P.I.C. has built up to now, every one of which is of fireproof construction cost on an average 36½¢ per square foot . . . previous to the creation of the P.I.C., Baltimore city had very little playground in connection with its schools. Some of the schools did not have any playground at all. All of the schools

we have built have been provided with playgrounds.'

A tribute to him appeared in a brief editorial in the Baltimore *Sun* of February 9, 1928, headed merely, "Well?" The full editorial reads: "Chairman Robert Garrett and Jacob Epstein, during the last campaign, said they would resign at the conclusion of the municipal building program then underway. The program has been completed. The Post can see no reason for Mr. Epstein to resign."

On April 16 the *Sun* editorialized on the work of the P.I.C., mentioning Jacob Epstein particularly, and saying: "In all its work, Mr. Epstein has been an active, forceful, and self-sacrificing member. He speaks with modesty when he says 'I have done my share as a citizen of Baltimore.' Mr. Epstein has done very much more than his share."

On May 1, 1928, Mr. Epstein was urged to reconsider his resignation from the P.I.C., which had prepared a resolution praising his services during seven and one-half years since its creation and declaring that his withdrawal would be a loss to the commission and the public. At a meeting of the P.I.C. he was praised highly for his work by several members, who spoke of his devotion to the city's welfare. When they asked him to reconsider his resignation, he replied: "I feel like the Negro who was charged in court for stealing a suit of clothes. His attorney pleaded so eloquently that the Negro was acquitted. As they left the courtroom the attorney asked, 'John, did you steal that suit of clothes?'' The Negro replied, 'At the time I thought I stole that suit, but you talked so fine that I now don't think I did.'" Mr. Epstein eventually insisted that his resignation stand.

During the years of his service on the Public Improvement Commission, Jacob Epstein occasionally accepted other appointments, and he never neglected the opportunity to remind the city how he felt politically. His appointments included one by Governor Albert C. Ritchie to the Board of Directors of the Hospital for Consumptives of Maryland—to which he was later reappointed—and one to the Divisional Chairmanship of the Red Cross. In the latter capacity he took occasion to send out, at his own expense, a circular letter appealing for help for victims of a disastrous flood in Florida.

In the mid-1920s an article about Jacob Epstein in *Credit* magazine related:

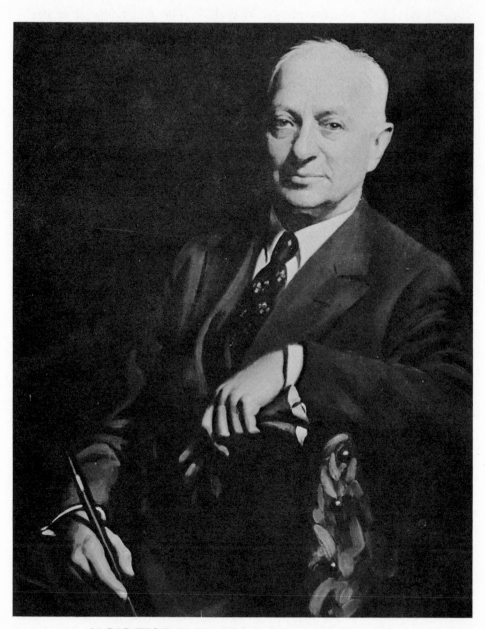

JACOB EPSTEIN BY THOMAS C. CORNER c1930

In addition to his better-known activities, he was a member of the Board of Supervisors of City Charities, Board of Eudowood Sanitorium, Vice-President of the Industrial Corporation of Baltimore City, Director of the Baltimore Steam Packet Co., member of the board of the Continental Trust Company, Merchants and Manufacturers Association, National Exchange Bank, Baby Milk Fund Association, Vice-President Maryland League to Enforce Peace, member of the executive committee of the Baltimore Chapter, American Red Cross, executive committee of the National Association of the owners of Railroad Securities.

As for his political affiliations, they were again demonstrated by a two-page article in the Sunday *American* in May, 1922, entitled "Great Work Done in Broening Regime." And in November, 1924, just prior to a presidential election, Mr. Epstein placed a half page advertisement in the *Sun* addressed "To All Men and Women in Maryland" and entitled "Stop, Look, Listen." He urged the election of President Coolidge, declaring that if he received less than a majority of the electoral votes there was a chance that William Jennings Bryan might be chosen president. In that case, said Mr. Epstein, business would become unsettled and people would be thrown out of work. He concluded, "I have not been asked by anybody to write this article, and . . . am paying for it out of my own pocket. . . . Play safe, don't run into danger."

His aid and his inspiration continued to be called for by communal institutions in need of help. Age did not deter him. In 1935, after he had passed seventy, he was the honored guest and principal speaker at a luncheon for workers in a drive to raise funds for The Johns Hopkins Hospital, a campaign of which he was an honorary chairman.

In 1940 he became tremendously concerned about America's probable entry into World War II. He carried on a voluminous correspondence with one of the ablest and most respected members of the United States Senate, Millard E. Tydings of Maryland, in which he indicated his knowledge of the large fleet being built by the Japanese government, one that included at least more than half a dozen battleships of 45,000 tons or more. He feared that this would give Japan dominance over the United States in the Pacific Ocean and urged that we waste no time in building additional large ships to prevent a Japanese take-over.

Shortly after our entry into the war, Mr. Epstein was fearful that the Japanese were securing fuel for their battleships from agents on the North American continent, either through fifth columnists or through pro-Axis neighbors in Mexico. He suggested that we offer enormous rewards to anyone advancing information leading to the arrest and conviction of individuals or companies responsible for supplying the German or Axis U-boats with gasoline or oil.

This correspondence included not only many letters to Senator Tydings but also articles of appreciation from James Forrestal, Acting Secretary of the Navy, and copies of letters from Secretary Knox of the Navy as well as other important private and public persons. These letters indicate the great keenness of Mr. Epstein's mind right up until two or three years before his death.

In June, 1943, he addressed a letter to the General Secretary of the Federal Council for Churches of Christ in America, calling attention to an article they had issued entitled ''Mass Murder of Jews in Europe.'' He appealed to the Council of Churches to take the lead in warning the people of Germany that they would be held to strict accountability for the atrocities against the Jews.

During World War II a letter from Mr. Epstein was published in the Baltimore *News* advocating the establishment of a universal language for the nations of the world. He felt this would result in a common understanding among world delegates to the peace conference that he was sure would assemble after the close of the war, and would avoid the friction likely to occur if one nation attempted to impose its language on another. He recommended that Esperanto (invented in 1889) be adopted and he asked the *News* to campaign for it. His letter created a lot of interest, which waned until the 1945 gathering in San Francisco for the formation of the United Nations, when the subject was revived. A fresh article in the *News Post* included Mr. Epstein's statement that when nations talked to each other through interpretors, the translations result in the loss of much of the original meaning. He felt that a universal language would be the greatest peace factor ever devised.

His crusade was for a noble cause, one that might have had lasting beneficial effects had it been universally favored—and the civilized world might have recognized another overwhelming debt to Jacob Epstein.

The Art Collection

Since the beginning of this century, men of means have looked abroad to enhance American culture. Some have acquired fine books and built great libraries; others have looked for works of art to build fine collections. The art collection of Jacob Epstein eventually became known to the connoisseurs and important art dealers in the western world.

It started on a comparatively modest scale, with acquisitions, through reputable dealers, of paintings from artists of the nineteenth century. The first acquisition record available appears on January 2, 1906, when Mr. Epstein purchased at auction for $4300 a picture by Tryon entitled *Souvenir de la Ferme de St. Augin.*

Other purchases by artists highly regarded at the time, and whose names still have some prestige today, followed shortly thereafter. There was De Neuville, a Frenchman, famed for his battle scenes (Mr. Epstein bought his *Officers Reconnoitering*.) There were other Frenchmen, who, like Tryon, belonged to the Barbizon school, which Mr. Epstein favored strongly — Diaz, Dunez and Daubigny, along with George Innes, an American who was influenced by the Frenchmen of that school. Later the works of better-known Barbizon artists were acquired — Corot and Jean Jacques Rousseau.

Other important names, too, appeared in the collection he was building — Cezanne of the impressionist school; Munkaesy, Hungary's greatest artist of the period (represented in the collection by *The Last Hours of a Condemned Man*); Otto Schreyer, an Austrian who painted beautiful horses (Mr. Epstein acquired his *Charge of the Arabs*); Thurlow, a Norwegian and the brother-in-law of Paul Gauguin; Messdag and Mauve, two Dutchmen of the Hague School, along with several works of another great nineteenth century Dutch painter, Josef Israels. Mr. Epstein's recognition of the worth of Israels came early. In 1908 he had acquired an Israels that had cost him $15,000, and he allowed it to be

displayed at an art exhibit held by the Baltimore Council of Jewish Women. Among his Israels paintings were two more great works of art, *Dutch Woman and Babe* and *The Jewish Wedding*; the latter was given to the art museum in Tel Aviv in 1936.

The first public showing of a group of Jacob Epstein's collected art works took place in 1923 when the Baltimore Museum of Art—then in a private home on Mt. Vernon Place—staged its inaugural exhibition. A private viewing which preceded the public display was held on February 20. It included three works loaned by Mr. Epstein; Jean Baptiste Famille Corot's *Bergers d'Arcadie*, Charles Gazin's *Arc en-Ciel,* and Josef Israels' *Reverie.*

Soon Mr. Epstein became interested in much bigger game, and he turned for help to his friends at New York's Knoedler Galleries and to Sir Joseph Duveen of London, one of the most knowledgeable men in his field, who obtained for him a number of the masterpieces that now grace the walls of the Baltimore Museum of Art. For authentication of the canvases that he had his eye on, he consulted the famous art connoisseur, Bernhard Berenson.

Quietly and without fanfare, one acquisition after another was made, as fine tapestries and bronzes were added to the works on canvas and wood. But not many people knew that Mr. Epstein was in the process of building an art collection that would one day be recognized from coast to coast and across the Atlantic.

In the mid-1920s he arranged to sit for Sir Jacob Epstein, the renowned English sculptor. The resulting bronze was far from flattering; many people, including Mr. Epstein himself, felt that the sculptor had failed to capture the attractive personality of his subject. Nevertheless, the bust was put on display at the Museum of Art.

By 1924 there was a clear demand for a new museum in Baltimore, one large enough to display the treasures that were being turned over to it, as well as the many important works of art that it was confident would be secured in the years ahead. A $1 million loan for that purpose was approved by the voters, and Mr. Epstein was appointed to a commission that would oversee the erection of that building.

When Mayor Howard Jackson announced the appointment of the museum's first Board of Trustees, it naturally included Mr. Epstein. One

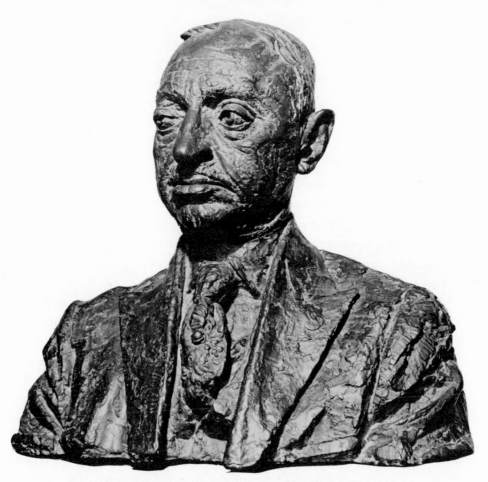

JACOB EPSTEIN BY JACOB EPSTEIN c1926
COURTESY EPSTEIN COLLECTION
BALTIMORE MUSEUM OF ART

of the Board's early actions was to purchase for $75,000 the building that then housed their treasures.

The committee on which Mr. Epstein was serving made a careful study to select the best site for the new museum. Some wanted it in the Wyman Park area; others thought Druid Hill Park was an ideal location. Among those favoring the Druid Hill Park site was Jacob Epstein, and he did everything he could to influence a majority of the board members to side with him. He entertained the board at his home, and used his great persuasive powers. However, this time he was not persuasive enough. The board voted 8 to 7 that Wyman Park was the better site, and so it was decided to acquire property there and proceed with plans for the new building. The cornerstone was laid in October, 1927 and the museum was completed and opened in 1929.

For that opening, Jacob Epstein loaned the choicest items in his collection; moving them into the museum secretly at night. The Epstein works of art dominated everything else on display, for by now he had accumulated a number of truly great masterpieces. Eclipsing all was the spectacular *Rinaldo and Armida* of Van Dyck. This stunning work, almost eight feet square, was, according to Dr. Gertrude Rosenthal, Chief Curator Emeritus of the Museum, the real star of the collection, probably the museum's most valuable picture. Its present value is estimated at $1,500,000. It represents the only literary subject ever painted by Van Dyck. When the director of the Musée de Beaux Arts of Brussels visited the Baltimore Museum of Art in the 1950s, he could only agree that *Rinaldo and Armida* was one of Van Dyck's masterpieces, adding, "If you will give it to me I'll carry it on my back across the ocean."

Dr. Rosenthal in a publication of the Baltimore Museum of Art, in 1959, commenting on the *Rinaldo and Armida,* wrote: "Because of its superb quality, unusual subject matter and historical importance, this large composition occupies a very special place in the oeuvre of one of the world's great painters. Paul Fierens, the late Director of the Royal Museums of Belgium, expressed this aptly when looking at the picture he stated that of the Flemish paintings in American collections he would want most to return *Rinaldo and Armida* to its land of origin. It was painted in Antwerp in 1629, a date confirmed by original documents dealing with the purchase of the painting for the art collection of King

RINALDO AND ARMIDA BY VAN DYCK

Charles I of England. There is reason to believe that Van Dyck owed his appointment as painter to the English Court to this work, which served as his card of introduction. ᴀ̶ᴛ̶ᴇ̶ʀ̶ ̶ᴛ̶ʜ̶ᴇ̶ ̶ᴋ̶ɪ̶ɴ̶ɢ̶'̶s̶ ̶ᴅ̶ᴇ̶ᴄ̶ᴀ̶ᴘ̶ɪ̶ᴛ̶ᴀ̶ᴛ̶ɪ̶ᴏ̶ɴ̶ ̶ᴛ̶ʜ̶ᴇ̶ ̶ʀ̶ɪ̶ɴ̶ᴀ̶ʟ̶ᴅ̶ᴏ̶ ̶ᴀ̶ɴ̶ᴅ̶ Armida was auctioned off and shortly afterwards came into the possession of the Dukes of Newcastle, where it remained until 1913. Mr. Epstein acquired the painting in 1927 from M. Knoedler and Company," for $250,000.

The announcement of the sale sent ripples through the entire art world. Newspapers and magazines in America and abroad spread the word that a comparatively unknown collector had walked off with one of the most famous paintings of the great Flemish master. In describing the purchase none of the media told of Mr. Epstein's innumerable philanthropic activities; they said only that he was a successful Baltimore businessman. The art world came to know more about his great philanthropies later, when the gems of his collection were given to the city of Baltimore for the art museum (the Van Dyck, which had hung in Mr. Epstein's home on Eutaw Place, was placed in the museum in 1929.)

In March 1927 another great work was added to the swelling Epstein collection, this time a Raphael. Again the price was high—$200,000 or more. The picture, a portrait of Emilia Pia de Montefeltro, painted on wood and measuring eleven by seventeen inches was acquired through the F. Kleinberger Galleries in New York. It was done when Raphael was about twenty-one years of age. After having been lost for two centuries, it was discovered in a dust-filled room in an old Vienna cottage by Dr. George Gronau, the former director of the Cassel Gallery in Cassel, Germany. Its history was vouched for by Bernhard Berenson. Though a few professionals in later years were skeptical about the authenticity of the work, that doubt has apparently been dispelled; the art world is satisfied that the Epstein collection does indeed contain a genuine early Raphael.

From 1926 to 1928 Mr. Epstein continued to buy great works of the old masters. In a detailed catalog published by the Baltimore Museum of Art in 1929, appear descriptions of some of the most famous works in the collection. Among them are examples of Sustermans, a Titian, a Goya, a Tintoretto, A Hals, a Rembrandt, a Gainsborough, a Tiepolo, a Raeburn, a Veronese, and a Reynolds. The collection does not confine itself to any one school or period, but contains examples of all the great schools of the

past; the Italian, the Flemish, the Spanish, the Dutch, and the English.

One of the earliest masterpieces is *Portrait of a Gentleman* (Fulvio Orsini), by Titian, painted in 1561 characterized by Mr. Walter Heil, Director, California Palace of the Legion of Honor, San Francisco, as "one of the best, if not the best, works by Titian in America." The renowned Dr. Bernhard Berenson (considered the greatest expert on Italian art) stated before Mr. Epstein's acquisition of the portrait, that the Titian was going into the list he was preparing on all the authentic Italian paintings known to him.

Another of Mr. Epstein's purchases was Sustermans' portrait of a nobleman of the Medici family. It is dated about 100 years after the Titian. This Dutch masterpiece was purchased in May 1928, by Knoedler and Company. It measured 80 inches by 44 inches. In the May 1928 number of the Art Journal "Apollo," Mr. William Gibson says "Noticeable above all others is the magnificent portrait supposedly of Cardinal Gian Carlo de Medici, for Sustermans was painter to the Florentine Court." This painting, incidentally was shown at the New York World's Fair in 1939. Another Sustermans acquired by Mr. Epstein was *Full Length Portrait of a Lady of the Medici Court,* a stunning picture of a handsome woman in full court regalia.

The *Portrait of a Young Woman,* by Franz Hals the Elder, purchased early in 1924 from Sir Joseph Duveen is considered by some critics as one of the handsomest female portraits that Dutch artist ever painted.

As regards his Goya portraits of the Spanish school, and some of the Italian and English pictures, a letter written by C. H. Messmore, vice president of M. Knoedler & Company says: "The Spanish School is represented by a fine Goya portrait of Don Antonio Raimundi Ibanez. Of the Venetian School, besides the Titian mentioned above, there is a Tintoretto and a Tiepolo portrait. The English school is represented by a very fine example of Reynolds' *Lady St. Asaph and Her Child.* It is a rare combination of brilliant coloring, happy composition and distinguished portraiture, and is one of the very finest examples of painting of that school. The Gainsborough portrait of *Mrs. Tudway* is a fine example of his early period while he was in Bath, and the later portrait of *Robert Adair* shows him in the fullness of power. There is also a fine Raeburn portrait of the *Earl of Hardwicke.* Mr. Epstein is to be congratulated on

the richness of his collection."

Several great Rodin bronzes were added to the collection—the famous *Le Penseur* or *The Thinker,* which graced the museum's marble front steps until a few years ago, when fear that it might suffer permanent damage from the fumes of passing automobiles caused it to be placed inside the building; *le Baiser* or *The Kiss,* probably Rodin's tenderest piece; and the equally well-known *Eve.*

Mr. Epstein admired the bronzes of Antonie Louis Barye, the great French sculptor of animals, and he purchased some fine examples such as *Lion and Serpent, Greyhound and Hare,* and *Panther and Stag.* In addition, he kept dozens of the smaller pieces in his office. Whenever a grandchild married, he or she was invited to select 21 Barye's from Mr. Epstein's collection.

He also was impressed by the miniatures of Louis Rosenthal of Baltimore, and many of them were turned over to the museum.

From time to time Mr. Epstein would receive requests from museums for the loan of some of his works of art. As an example, in 1929 there was a huge exhibition of the Dutch Masters in Burlington House, London, which included Rembrandt's *The Old Man with Red Cap* from the Epstein collection.

When he was in London one year in the late 1920s, Mr. Epstein decided to have his portrait painted by one of England's most popular artists, Sir William Orpen. Sir William's fame was such that he was not obliged to seek commissions but could select the subjects he wanted and decline those who did not interest him. When Mr. Epstein called on him, the painter looked at him coldly and said he was not interested in painting him. Mr. Epstein calmly picked up his coat, his hat, his gloves, his cane, and his cigar and started for the door. Sir William suddenly seemed to see him in a new light. He called out, "Wait a minute," and Mr. Epstein turned, coated, hat on head. The artist said, "I would like to paint you, just like that." The result was a likeness that brought out the character of the subject as not even a photograph could do. It exuded Mr. Epstein's confidence, his benignity, even his sly sense of humor. The picture now hangs with the other paintings in the Baltimore Museum of Art collection.

Other important artists who painted Mr. Epstein's portrait were Augustus John and Sir Oswald Birley.

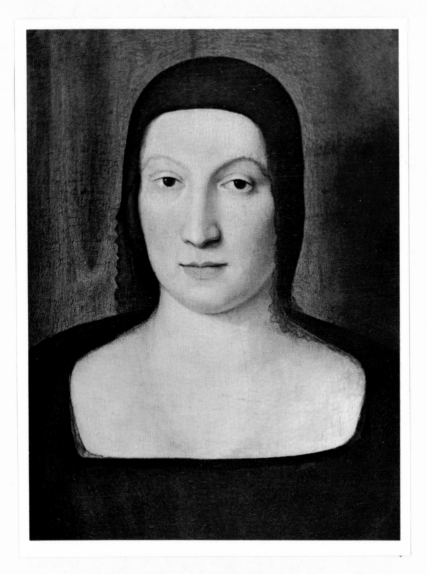

PORTRAIT OF EMILIA PIA DE MONTEFELTRO BY RAPHAEL
COURTESY EPSTEIN COLLECTION
BALTIMORE MUSEUM OF ART

Occasionally Mr. Epstein would visit the museum. Whenever he did, there was great excitement, for he was beloved of all the staff. He was particularly kind to the people in the lower echelons—the porters, and "Mo" the art packer.

At his death in 1945, when his will was examined, it was found that all of his works that were on loan to the Baltimore Museum of Art had been given to the City of Baltimore, to which the museum belonged. Many other fine pieces remained in the possession of members of the family.

The Jacob Epstein collection, with its stunning array of works of the old masters, its bronzes, and tapestries, plays an integral part in making the Baltimore Museum of Art a great cultural center, and is far more valuable today than when the gift was made.

The Later Years

After the American Wholesale Corporation had been sold, the firm took offices at 10 Light Street where they conducted the affairs of their investment company, the American General Corporation. Mr. Epstein would usually arrive about noon.

On summer days he was often soaked in perspiration, after the several mile walk that he took to his office. He would take off his damp linen and hang them over a chair to dry, then he would pick up from another chair the clothes that had been drying out from the day before (when he had had a similar experience) and put them on. Then he would proceed with his business. After lunch which consisted of zweibach and honey, and which he took at his desk, he would sleep for a while on his office couch-bed. After his nap he would consult with his sons-in-law, keeping them with him until almost eight o'clock. Dinners were always held up until the men got home, despite the hardship on the households.

In 1924 he had decided to start a business for the benefit of his grandchildren, so he put $700,000 ($100,000 for each grandchild) in trust for this purpose, naming as trustees his two sons-in-law and himself. The trustees determined to enter the chain store business and they sought out Charles and Harry Coplon, who had opened a "soft goods" store in New Bern, North Carolina, and shortly afterward opened two more stores in the same state. The trustees had confidence in the ability of the Coplons and entered into a partnership agreement with them, with the understanding that the new capital poured into the venture would be used to open new stores. Within six years the chain, known as The Charles Stores, grew to more than 30 units, most of them in the south, but one—as a kind of daring experiment—in New York City. The operation sailed along smoothly until the Depression of the 1930s, when the profitable years came to an end.

In 1935 the trustees bought out the interest of the Coplon brothers

(sons of the Solomon Coplon, who clerked for Jacob Epstein in the early 1880s). They then persuaded Benn Hornstein, at that time associated with Butler Brothers, to associate himself with the Charles Stores as chief executive officer, and they advanced him money to buy a one-third interest in the chain. In 1951 the Lansburghs sold their one-third interest to the Katzs, and by 1957 the Katzs had disposed of all of their interests to Benn Hornstein, who, in 1959 sold the stores to United Whalen.

In celebration of Mr. Epstein's seventieth birthday, four hundred of his friends and admirers gave a testimonial dinner for him at the Southern Hotel, with his esteemed Rabbi, Dr. William Rosenau, serving as chairman of the Dinner Committee. Addresses were made by the governor, the mayor, and a number of community leaders. One of his ardent admirers, Joseph Katz, an advertising man, composed for him this printed tribute.

When I was a lad I looked up with awe at the heroes in the Horatio Alger stories. When I grew up I met one in real life—Jacob Epstein. Here is Will Rogers in Business. Here is Plato and Mark Twain. Here is a man who has made a business of the other fellow's business—who has appointed himself General Manager of the "Less Fortunate"—who gets keen delight out of doing something for others. You can't say "Baltimore" to anyone without hearing "Jacob Epstein." He is the town's best asset.

One of life's greatest joys is to have his friendship. He's really a man in a million. Men like him are scarce—and I hope he will be with us for many, many more years. I love him. We need him.

Mr. Epstein was not a fluent linguist, but because of the great amount of time he spent in France, he was anxious to be able to converse in French. When he was about seventy years old he took French lessons at the Berlitz School in Baltimore, and private lessons in France, where he sat in the sun on the Promenade des Anglais in Nice, always with a pretty teacher. He was a diligent pupil, and his study of the language gave him confidence to participate in conversations and discussions. He used to say that it was easy to find a good talker, but hard to find a good listener. In Paris, he sometimes professed loneliness, as was mentioned earlier, but he was never lonely in Nice.

On a few occasions he would spend time in Vichy or in Plombier-les-Bains, but Nice was his favorite vacation spot, and the Negresco was

JACOB EPSTEIN (BUDDY), HARRIET, KAUFMAN RAY (KOFFY) KATZ
c 1937

his favorite hotel. All the staff knew him and catered to his wishes. When he arrived for his regular stay there, the man at the desk and the bellboys overlooked his worn, scarred, old-fashioned luggage and strove to give him every attention, as did his waiters in the dining room. If his room was too hot or too cold, he had only to mention it, and the temperature would be regulated. If he wanted to converse with friends at the dinner table and the orchestra was playing, a signal from him to the leader would stop the music. He practically ran the hotel.

Some of his French friends enjoyed the horse races and would urge him to accompany them and place a few bets. Mr. Epstein declined, saying, "If instead of betting on each race you would take your money out of one pocket and put in in another pocket, at the end of the day you would have $40."

He disliked being overcharged. One day he asked a French newsboy for a five cent newspaper. The boy told Mr. Epstein the price was ten cents. He declined to buy it and went to another boy who offered him the paper for five cents. Mr. Epstein gave him a dollar.

In 1938 while in France Mr. Epstein suffered a sudden heart attack. The family in Baltimore, advised of Mr. Epstein's illness, felt he should be brought home right away. Accordingly, Koffy Katz, his oldest grandson, was immediately dispatched to France to take charge of the situation. When he arrived outside Mr. Epstein's room in the Negresco, the door was closed. Koffy knocked cautiously and his grandfather called out, "Who is it?" "It's Koffy," replied his grandson. "Oh," said Mr. Epstein, "Please come back in an hour." Koffy retired and an hour later his grandfather allowed him to enter the room. It appears that he had been engrossed in reading the financial news in the papers and did not want to be interrupted.

Koffy arranged to escort him back home on the Rex, but Mr. Epstein could not be kept from his beloved France. The next year, just a few months before the outbreak of World War II he returned there again. His family was concerned for several reasons; they worried about his physical ability to stand the trip, and they were convinced that war was imminent. But, as usual, he made his own decisions, and he had decided on one more trip to France. This time, however, his stay was cut short by Germany's impending invasion of Poland, and like thousands of other Americans, he

ROBERT, SIDNEY, JR., ELIZABETH (LIBBY), AND
RICHARD LANSBURGH c1931

had to clamor for space on a western-bound vessel. With the assistance of Joe Tabbagh, he booked passage on the Queen Mary, late in August 1939. War broke out on September 1. The Queen Mary steamed home three days later without incident, except that all lights were blacked out at night.

Mr. Epstein had always been particularly helpful to young people, and he had an opportunity to exhibit this trait again. Roger Greif, the son of Leonard and Amy Greif, Mr. Epstein's friends, had been working at the University of Zurich Medical School just before the outbreak of the war. He wanted desperately to get home but could not find steamer space. Word of his plight came to Jacob Epstein, who invited him to share his cabin with him; the offer was eagerly accepted. Roger still remembers how he used to watch ''a jauntily attired old man promenading the deck.'' When he stepped off the boat in New York, an anxious family was at the dock awaiting his arrival. They found him in fine shape.

Mr. Epstein was never able to return to France, but spent his winters in Palm Beach at the Mayflower Hotel. Summers were spent in Atlantic City. He enjoyed the Ambassador or the Ritz, but during the war years these were taken over by the military forces for the wounded and convalescing, so that their former residents had to seek boarding houses. Mr. Epstein found rooms with a family named Bernstein. He had with him his attendant, Jack Freeman, as well as some good friends to keep him company.

During those later vacation years he discarded the dapper apparel that he wore at home; his summer beach costume usually consisted of a pajama jacket, whitish pants, high black bedroom slippers, and a straw boater.

On his eightieth birthday, December 28, 1944, which he observed in Palm Beach, his friends in Baltimore hit on a unique method of conveying congratulations. A number of speakers expressed their respect and felicitations at a local radio station where a disc was made and sent to Palm Beach. The station received specific instructions as to the exact time for the record to be played. Mr. Epstein, instructed to tune in to station WWPG at Palm Beach the afternoon of his birthday, heard the following:

Announcer. A birthday party for Mr. Jacob Epstein.

Voices: Happy birthday to you,
Happy birthday to you,
Happy birthday, Jacob Epstein,
Happy birthday to you.

Announcer. The next voice you hear will be that of Theodore R. McKeldin, Mayor of Baltimore, Maryland: Mayor McKeldin.

Mayor McKeldin. Good afternoon. First I would like to explain to you folks in Palm Beach why we, in Baltimore, have engaged a half-hour on your radio station to hold a birthday party in honor of a Baltimore man. You see, Mr. Jacob Epstein of Baltimore, who is eighty years old today, is spending the winter in your lovely state of Florida. In Baltimore, for many years, Mr. Epstein has been recognized as our leader in every philanthropic effort. Not only has he contributed generously to every charitable and civic cause, but he has given us a personal leadership that has been indispensable. Even in recent years, when Mr. Epstein had reached an age that would entitle him to retire gracefully to the background, he has carried on his philanthropic interests with a vigor that has been an example and inspiration to the younger generation.

And now that Mr. Epstein has reached the grand age of eighty, we in Baltimore want to give him a party. But we wouldn't dare ask Mr. Epstein to leave the lovely sunshine of Florida even for an eightieth birthday party—so we are using this radio program to bring his party to him here in Palm Beach.

Mr. Epstein, in the name of the City of Baltimore of which I have the honor to be Mayor, I want to pay tribute to you for your contributions to the building of our city—as a great and successful merchant; as a man with a sense of civic responsibility for more than half a century, actively interested in every movement that would benefit the City of Baltimore; as a patron of arts and a collector of masterpieces of painting and sculpture; and as one of our great philanthropists. A happy birthday to you, Mr. Epstein, and many, many more.

And now, I bring to the microphone your good friend James Hepbron to extend you greetings on behalf of the War and Community Fund of Baltimore.

Mr. Hepbron. A few years ago I chanced to stop in a little Russian town called Stepanovka. In its central square stood a magnificent stone. My guide pointed it out with reverence and affection. "That is the Monument to International Friendship," he told me. "It was erected in honor of John Howard, an Englishman, who so bravely tried to stamp out an epidemic of plague on our Ukraine steppes." He ran his fingers over

103

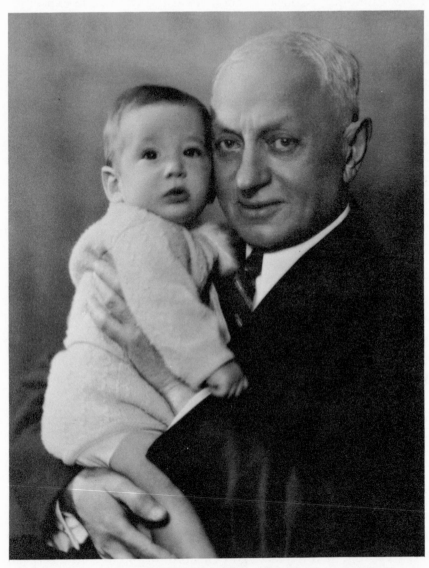

JACOB EPSTEIN WITH HIS FIRST GREAT-GRANDCHILD,
KENNETH GRIEF c1934

the letters lovingly. "The grateful Russians wrote this," he said. "Read it; aren't the words beautiful? 'Whoever thou art, thou standest now beside thy friend.'"

I have never forgotten those simple lines, and I quote them today because they might so well be a living testimonial to one who, throughout his entire lifetime, has demonstrated himself a friend to all, whether rich or poor, happy or afflicted.

As Director of the Community Fund of Baltimore, I can tell you that my city has never had a better friend than Jacob Epstein. It is to him that Baltimore owes the Mount Pleasant Sanitorium, founded and built at his expense. It was he who erected a fine building at the nonsectarian Eudowood Sanitorium and who also donated the building and grounds for our original Hebrew Home for Incurables.

For half a century Baltimore has known his generosity and his kindly charity to all in distress. As a practical humanitarian, Mr. Epstein's name is—and always will be—inevitably associated with that social service work of the warm personal sort . . . which we call friendship.

Mayor McKeldin. Mr. Epstein, while we take pride in the fact that your gifts and contributions have been given with a generous hand regardless of race or creed, yet we know that close to your heart are the Jewish charities of Baltimore to which you have contributed leadership in direction and organization, as well as setting an inspiring example in giving. And I know you will be glad to hear the voice of Lester Levy speaking for the Associated Jewish Charities and the Jewish Welfare Fund.

Mr. Levy. It is our privilege today to salute and congratulate the man who, for half a century, has been recognized as the philanthropic leader of the Jewish community of Baltimore. Jacob Epstein is a generous man; but he is more than that. His generosity has been an active force that has extended beyond his own great personal benefactions and entered into the spirit of a whole community. Always kindly, always approachable, with a salty vigorous humor and a feeling for the richness of life, he has been moved by a deep sense of responsibility to see that the privileges inherent in living were brought within the grasp of thousands of his less fortunate fellowmen—in his own city, among his own people, and to other cities and other peoples across the face of the earth.

105

When Mr. Epstein was a young man beginning to make his mark in Baltimore, the city had no association of Jewish philanthropic institutions. Charity was a personal matter, between individuals.

We know that Mr. Epstein did his share of personal charity. But to a man of his vision, that was not enough. Through his efforts, the combined charitable impulses of his people were channeled into one great cohesive driving force. He taught his city how to give.

Today in Baltimore, the Associated Jewish Charities and the Jewish Welfare Fund, through thirty-two separate agencies, bring help, physical and spiritual, to many thousands of individuals at home and abroad. Each year we raise well over a million dollars for these causes. We are proud of our achievements. But they would never have been possible if we had not had Jacob Epstein to lead us. More than any other single person, he has taught us the real meaning, the real power of charity. Mr. Epstein, the Baltimore Jewish Community congratulates you on this, your eightieth birthday. We wish for you many more years, to be spent in health and happiness with your family and your many devoted friends.

Mayor McKeldin. Mr. Epstein, you know how proud we are here in Baltimore of our wonderful Baltimore Museum of Art. And we in Baltimore know how much your interests and your patronage of the fine arts has meant to the success of the museum. So, I'm sure you'll be happy to hear from Mrs. Adelyn Breeskin, Acting Director of the Baltimore Museum of Art. Mrs. Breeskin.

Mrs. Breeskin. Our museum has every reason to be deeply grateful to you, Mr. Epstein, for your great generosity in allowing your fine collection of paintings and sculpture to be on view in a special gallery, for the benefit of hundreds of thousands of people who admire them constantly. I take this opportunity to greet you in their behalf and to wish you a happy birthday. I also send you the heartiest congratulations and best wishes of our Board of Trustees as well as our museum staff. In point of seniority you are our top-ranking board member. For many years your interest in and support of our institution have helped to make it grow to its present splendid proportions. Your many visits to us have been greatly appreciated and when you are away we miss you. Then your spirit seems to hover over the figure of Rodin's *Thinker*, which dominates the entrance steps to our building. This gift from you adds great dignity to the

106

impressive approach to the museum and draws crowds who stop to study it before entering our portals. Once within they flock to admire your gallery, where *Rinaldo and Armida* first attracts their attention—a mighty picture in its proportions, color, and rhythmic composition. Nearby they find the Raphael portrait of Emilia Pia de Montefeltro, a distinguished picture of a distinguished personage, which contrasts most interestingly with the Flemish painting of the Magdalene by the Master of the Half Length. Titian, Tintoretto, Veronese, Rembrandt, Hals, Rubens, Sustermans, Goya, Reynolds, Gainsborough, Raeburn—all of these and more are known to hundreds of thousands of Baltimoreans through your generosity and we send you their gratitude for the stimulating pleasure that these works of art have afforded to so many. We offer you their thanks and our thanks for giving us the opportunity to know these mighty pillars of our spiritual heritage on which we lean in times of stress and strain such as the present world allots to us. They give us strength to carry on and to fight for ideals which they so nobly represent. They also reflect honor and glory to you, to whom we extend our heartiest good wishes.

Mayor McKeldin. Mr. Epstein, no review of Baltimore philanthropic organizations would be complete without recognizing the magnificent structure of institutions and agencies gathered together as the Bureau of Catholic Charities. And on their rolls of contributors, too, the name of Jacob Epstein occupies a prominent place. It is with great pleasure that I bring to the microphone your great friend, Father Daly.

Father Daly. Mr. Epstein, it is indeed a pleasure to participate in this novel program of tribute to you on this occasion. It always seemed to me that no finer tribute can be paid to a man than to say that his life is useful. Especially is this true when the usefulness has been all inclusive. Truly, you have been, are, and always will be, useful.

You have been useful in that you built a large business that has given employment to thousands.

You have been and are useful in that you manifest a deep interest in all the more important matters of civic life and more particularly in those phases involving the needs of less fortunate fellow citizens, whose sufferings were either chronic or brought on by the emergencies of life.

You are useful in the great generosity with which you support all movements for the relief and succor of your fellow man.

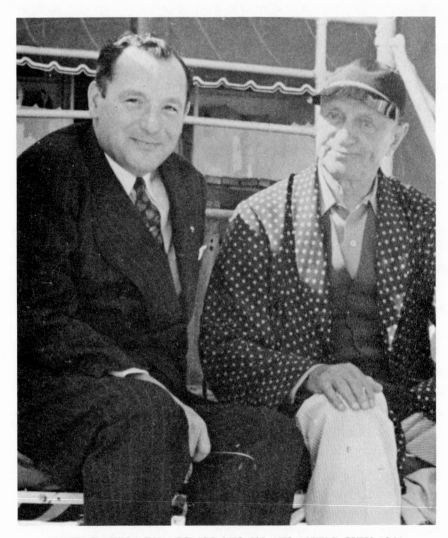

WITH RABBI EDWARD ISRAEL IN ATLANTIC CITY 1941

You have been and are useful in your willingness to extend your sound advice and tempered judgment on problems of social, economic, or civic import.

And of primary moment you are and will be useful in that you give a fine example to all by the correctness of your personal, private life and your consciousness of public duty.

And so, Mr. Epstein, on this anniversary, the Catholic Charities extend to you its gratitude for your many kindnesses and prays to our Heavenly Father that you will be spared many more birthday anniversaries in comfort, good health, and happiness. Its greeting is this: Happy Birthday to a Useful Man.

Mayor McKeldin. Mr. Epstein, even King Solomon who had a thousand wives, had a favorite. And among the myriads of causes you have espoused you, too, have a favorite—closest to your heart, perhaps, because it represents your own efforts to establish an institution very sorely needed in our community. Of course, I refer to the beautiful Mount Pleasant Tuberculosis Sanitorium, founded by Jacob Epstein. Here at the microphone to greet you is the president of Mount Pleasant, Calman Zamoiski.

Mr. Zamoiski. You, Mr. Epstein, on your eightieth birthday, are to be congratulated in many ways.

Thirty-six years ago you had foresight enough to see the need for a hospital, located in our great state of Maryland, that would care for and cure those suffering from a contagious and most dreaded disease. You therefore, in your great spirit of generosity, founded a hospital that would do just this for unfortunates, regardless of race, or creed. You gave this community a 136-acre tract of rolling country side, near the city of Baltimore, with all necessary buildings and equipment. The hospital—originally known as the Jewish Home for Consumptives, founded by Jacob Epstein, and later named Mount Pleasant—has cared for many thousands of people and returned them, health restored, to their normal way of living. Mount Pleasant is considered one of the most efficient and modernly equipped of tubercular hospitals and, through the years, has continued to be run according to the original high standards and policies outlined by you.

The patients, the staff, the Board of Directors, and the officers of

109

Mount Pleasant join me in sending best wishes not, only for your eightieth birthday but, God willing, for many more. Again—congratulations and God Bless you.

Mayor McKeldin. Mr. Epstein, although our great City of Baltimore has grown steadily and has extended its limits frequently in your lifetime, your influence has gone far beyond the boundaries of the city you love so much, and throughout the entire state of Maryland the name of Jacob Epstein is loved and respected. So it is now our honor to bring to the microphone our great Chief Executive, the Honorable Herbert R. O'Conor, Governor of the State of Maryland. Mr. O'Conor.

Governor O'Conor. As Governor of Maryland I have many pleasant duties to perform, but I can truthfully say, Mr. Epstein, that there is none more pleasant than that of saying ''Happy Birthday'' to Maryland's grand old man. Maryland owes a lot to you, Mr. Epstein. For many years as a leading business man and head of the Baltimore Bargain House, afterward the American Wholesale Corporation, you spread the fame of Baltimore and Maryland throughout the nation, particularly the south. Whenever there was a movement by business men of the state to do something to promote its markets or its products, we could always be sure that you, Mr. Epstein, were furnishing the ''horsepower'' to make the machinery run.

But you were always a citizen first and a businessman afterward. Because you were a great businessman you were a great citizen. Your contribution to the philanthropies and the cultural activities of Baltimore and Maryland have already been recounted. But you were never content with merely giving funds; you also gave intelligent direction to the use of those funds; you used your great executive ability to plan smoothly functioning institutions—and I may say you also used your ability in salesmanship to persuade hundreds of others to join you in setting a higher standard in their contributions to a myriad of worthwhile causes.

You never failed to throw your influence on the side of good government. Regardless of party or personality, anyone who sought to accomplish a constructive reform would be assured of your support.

So today—your eightieth birthday—is a happy one for all of us, and speaking for your many friends throughout Maryland, I say again, ''Happy Birthday and a Happy New Year.''

Mayor McKeldin. And now, Mr. Epstein, I want to turn over the microphone to a young man who has been one of your fellow workers in the field of charity for many years, a man who is at present "pinch-hitting" for Harry Greenstein, now in Cairo, Egypt, working with the United Nations Relief and Rehabilitation Administration — Milton Gundersheimer.

Mr. Gundersheimer. Happy birthday, Mr. Epstein. This is a grand party but I don't want you to get the idea that we don't still expect great things of you for many years to come. In the *Reader's Digest* I have just read about the accomplishments of some other young men. Verdi at the age of eighty produced *Falstaff,* and at eighty-five wrote "Ave Maria." Goethe at eighty completed *Faust.* Tennyson at eighty wrote "Crossing of the Bar," and Michelangelo completed his greatest work at eighty-seven. At the age of ninety-eight Titian painted his great picture, *The Battle of Lepanto,* and at ninety Justice Holmes was still writing brilliant opinions on the United States Supreme Court. And George Bernard Shaw at eighty-eight is still full of vigor and controversy.

So, you see, Mr. Epstein, we expect many more years of leadership and counsel, and I hope that in every community effort for years to come, we can look to Jacob Epstein for inspiration and encouragement.

In honor of this occasion your friend and neighbor, Amy Greif, has written a little song and I want you to hear it.

(Sung by Phil Crist to the tune of "The Band Played On")

> Many the men we have watched one by one
> as the years roll on!
> Few are the men who have done what you've done
> as the years roll on!
> Helping Humanity's every good cause,
> Seeking no praise, nor applause
> You've been the Man with the vision and plan
> As the years roll on!
> What could our city have done without you
> As the years roll on!
> Your fine example has fired us anew
> As the years roll on!
> Leader, Advisor, Philantropist, Friend

On YOU we have come to depend—
May each passing year find you flourishing here—
as the years roll on!

Mr. Gundersheimer. Well, no birthday party is a real party unless the
family is a part of it. So, representing the members of your family here's
your daughter Marian, with a greeting from the whole family.

Mrs. Sidney Lansburgh. Happy Birthday, Father. I wish we could all
be with you—or I wish you could be here and see your friends gathered in
the studio while we make this recording.

I feel that it's an achievement on my part to be the daughter of such a
great man and now that there are grandchildren and great-grandchildren in
the family, I'm hoping they may follow your footsteps.

We certainly feel proud when we hear what the Mayor and the
Governor and all the others have had to say about you. And we're proud,
too, of that indomitable spirit of yours which keeps you so young despite
those eighty years.

And now everybody in the studio is going to join with me in that good,
old song:

> *(Everybody in studio sings:)*
> Happy birthday to you
> Happy birthday to you
> Happy birthday Jacob Epstein
> *(fade)*
> Happy birthday to you
> *(applause)*
> *(Fade out)*

In commemoration of this occasion, Jacob Epstein's grandchildren
arranged for simultaneous dinners for the aged and infirmed residents of
Levindale, Mount Pleasant, and the home for the aged at Sinai Hospital.

A day before his eighty-first birthday, Jacob Epstein died in his sleep
at the Hotel Mayflower in Palm Beach. The funeral services were held at
Oheb Shalom Synagogue in Baltimore, and his body was placed in the
Epstein Mausoleum in Oheb Shalom Cemetery, a structure Mr. Epstein
used to refer to, humorously, as "my apartment house." Actually, it was a
handsome, dignified work of art, designed by the famous sculptress
Malvina Hoffman.

As expected, his euologies were many. People spoke of his rich personality, his innate modesty; they called him a benefactor of the community and an inspiration to all who had the privilege of knowing him.

His will, after providing substantially for a number of philanthropic interests, both Jewish and gentile, white and black, directed that half the residue be used to create a foundation to assist Jewish refugees and persecuted Jews abroad. His great art collection, housed in the Baltimore Museum of Art, a city-owned institution, was left to the City of Baltimore, thus perpetuating its place in the art museum.

No one who knew him will ever forget him. *Zecher Tsadik Livrochah*, "The memory of the righteous is a blessing."

Acknowledgements

This story of the life of Jacob Epstein could not have been written without the assistance of many members of his family, and acquaintances and interested people in various parts of the world.

I shall not mention here those of his grandchildren or other relatives who were so helpful, but I do want to acknowledge the information gathered, particularly from the following:

Mrs. Sarah Schuchat of Baltimore, descendant of the Klein family of Tauroggen, for her early recollections, and for the photograph of Jacob Epstein as a young man in company with her uncle.

Dr. Gertrude Rosenthal of the Baltimore Museum of Art for her knowledgeable appraisal of the Epstein works at that institution.

Adelyn Breeskin, former director of the Baltimore Museum of Art, for her pertinent recollections.

The Baltimore Museum of Art
The Maryland Historical Society
Judge Joseph Sherbow of Baltimore
Mr. Gilbert Sandler of Baltimore
Mrs. Edward R. Prince of Milwaukee, Wisconsin
Mr. George Bram Saroco of Lichtenstein
Mr. Joseph Tabbagh of Paris, France
Mr. Benn Hornstein of Palm Beach, Florida

Tailored Suits

W122 W123

W122 — Good quality all wool Diagonal Cheviot, 3-button coat, semi-fitted back finished at side with pleat and trimmed with silk braid and buttons, shawl collar, wide revers inlaid with striped corded silk and trimmed with buttons, new sleeves, good quality satin lining; high waisted skirt, panel back, front made with pleat and trimmed with buttons to match coat; colors—Black, Brown and Gray; sizes 34 to 40 suit, **$10.50**

W123—Good quality Whipcord, 2-button coat, semi-fitted back, finished with pleat at side and trimmed with small buttons, new sleeves, side pockets, lined throughout with good quality satin; high waisted skirt, panel back, front finished with wide pleat and trimmed with small buttons to match coat; colors—Gray and Tan; sizes 14 to 40, suit, **$10.50**

Junior Coats

W798 — Black Silk Plush, semi-fitted back, shawl collar, new sleeves, turnover cuffs, lined throughout with good quality black mercerized lining, each, **$6.00**

W787 — Novelty Cloaking, good quality, 3-button front, back trimmed with wide belt and large buttons, deep circular collar and wide revers inlaid with Ratine cloth in contrasting shade, trimmed with 4 large buttons, new sleeves, deep turnover cuffs to match, side pockets—colors—Tan and Light Gray, each, **$6.50**

W788 — Gold Brown Chinchilla, good quality, 2-button front, back trimmed with wide belt and large buttons, deep shawl collar of solid color cloth to match, new sleeves, turnover cuffs, side pockets ... each, **$6.50**

W788

Infants' Long White Slips or Dresses

W160 W161

W162

★ **W160** — White Cambric, yoke made with small tucks and 2 rows of lace insertion, edged with circular embroidery ruffle, collar edged with narrow lace, doz., **$1.75**

W161 — White Cambric, yoke of beautiful embroidery finished with 2 small side pleats, collar and sleeves edged with ruffle, hemmed at bottom, doz., **$2.25**

W162 — Soft finished Nainsook, yoke closely tucked and trimmed with row of openwork embroidery, collar and sleeves edged with ruffle, hemmed bottom, doz., **$3.75**

Other Wholesalers have different prices for different classes of Merchants. . . .

Children's Cloaks

W626 W627

W626—Good quality Zibeline, double-breasted front, deep velveteen sailor collar, finished on edge with wide silk braid, plain sleeves finished at cuffs with velveteen and braid to match collar, lined throughout with mercerized lining; colors: brown and medium blue each, **$2.25**

W627—Silk finish Corduroy, gilt buttons on front, trimmed with narrow silk braid and fur heads, turnover collar, plain sleeves, lined throughout with mercerized lining; colors: brown and navy each, **$2.25**

Dresses

W1984 W1985

W1984—Good quality Serge, deep turnover collar handsomely embroidered with black and white silk braid, front finished with 2 side pleats and trimmed with black and white striped velvet, new sleeves, turnover cuffs to match collar, attached belt, skirt made with side fold and 2 small pleats, trimmed with fancy buttons; colors—black and navy; sizes 34 to 40, each, **$6.7**

Slumber Robes

W1055 W1056

W1055—Flowered Flannelette, deep turnover collar, front of garment trimmed in contrasting shade, plain sleeves, turnover cuffs to match, heavy girdle at waist; 1 doz. assorted figured patterns to bundle, doz., **$9.0**

W1056—Good quality Flannelette, deep turnover circular collar inlaid with sateen, finished with narrow black and white braid, front made with 2 wide side pleats, plain sleeves, finished at cuffs to match collar, fastened at waist with girdle; ½ doz. assorted gray figured patterns to bundle, doz., **$12.0**